IN FOCUS

WILLIAM HENRY FOX TALBOT

PHOTOGRAPHS

from

THE J. PAUL GETTY MUSEUM

The J. Paul Getty Museum

In Focus
Photographs from the J. Paul Getty Museum
Weston Naef, *General Editor*

Getty Publications
1200 Getty Center Drive
Suite 500
Los Angeles, CA 90049-1682
www.getty.edu

Christopher Hudson, *Publisher*
Mark Greenberg, *Editor in Chief*

Library of Congress Cataloging-in-Publication Data

J. Paul Getty Museum.
 William Henry Fox Talbot : photographs from the
J. Paul Getty Museum.
 p. cm. — (In focus)
 ISBN 0-89236-660-5 (pbk.)
 1. Photography, Artistic. 2. Talbot, William Henry
Fox, 1800–1877. 3. Photography—Great Britain—
History—19th century. 4. J. Paul Getty Museum—
Photograph collections. 5. Photograph collections—
California—Los Angeles. I. Talbot, William Henry
Fox, 1800–1877. II. Title. III. In focus (J. Paul Getty
Museum)
TR651.J68 2002
770'.92—dc21 2002001385

Contents

Foreword

This volume in the J. Paul Getty Museum's In Focus series is devoted to William Henry Fox Talbot, a pioneering photographer who worked in England at the dawn of this new artistic medium. His experiments with the chemistry of light-sensitive silver led him into uncharted territory. Working even before the word *photography* was publicly used to name the new process, he called his early images "photogenic drawings."

Talbot's first surviving pictures were made without the use of a camera or lens. By placing specimens directly on sheets of specially coated, sensitized paper and then exposing the materials to the chemical action of sunlight, he created visually rich and inventive images. He went on to experiment with lenses mounted onto crude wooden boxes, and later, before anyone else imagined how to do so, he developed the chemistry to make multiple prints from negatives.

The Getty Museum houses one of the most significant collections of Talbot's work in the United States, numbering approximately 350 items. The holdings range from his first successes in the mid-1830s to his experiments with photomechanical methods in the 1850s. This book has been printed in full color so as to convey the luscious tones found in the negatives and positives.

On October 6, 2000, the Department of Photographs hosted a colloquium to discuss Talbot's oeuvre. That discussion formed the basis for this In Focus book, and I am grateful to the following participants for generously sharing their knowledge and expertise: Geoffrey Batchen, David Featherstone, James Fee, Nancy Keeler, Weston Naef, Larry J. Schaaf, and Michael Ware. In addition, Dr. Schaaf authored the introduction and plate texts for this publication and deserves particular acknowledgment and thanks.

There are many others, in addition to those listed on the last page of this volume, who contributed to this project and ensured its success through their dedication and hard work: Julian Cox, Marc Harnly, Lynne Kaneshiro, Ernie Mack, Marisa Nuccio, Ted Panken, and Jack Ross. It is to them and to Weston Naef, who devised the In Focus series and continues as its general editor, that I offer my appreciation.

Deborah Gribbon
Director, The J. Paul Getty Museum
Vice President, The J. Paul Getty Trust

Introduction

One of the most complex and human of stories in the history of art centers around the personal struggles and the scientific and artistic triumphs of William Henry Fox Talbot (English, 1800–1877). He invented photography as we know it, conceiving of the idea of a negative that could be used to make multiple prints on paper.

Talbot was so highly accomplished in such a diversity of fields that his life seems nearly unapproachable to us today. By the time photography was announced to the public in 1839, he had published two books and nearly thirty scholarly papers and had twice been recognized by Britain's premier scientific institution, the Royal Society. In addition to his research in Greek, mathematics, and botany, he became a member of Parliament and skillfully guided his village through the great civil disruptions of the 1830s. After the invention of photography, he turned to etymology, becoming a significant figure in the study of Assyrian cuneiform.

Talbot had been surrounded by artistic influences since birth. Members of his extended family were among the wealthiest individuals in England, and their personal art collections were extensive. Because his father died when Talbot was only five months old, he was largely brought up by his mother, Lady Elisabeth. The daughter of the second earl of Ilchester, she was a highly intelligent, well-educated, abundantly talented, and strongly opinionated woman who had an irrepressible interest in her son's intellectual growth. Her propensity for Continental travel brought him into personal contact with many of the world's fine art collections. She was an accomplished artist and lithographer herself and managed to

transfer many of these skills to her daughter Caroline. However, she must have felt sorely disappointed when it came to her son's ability with the pencil. As gifted as he was in so many areas, Talbot simply could not draw. He was miserably unable to translate the complex and colorful three-dimensional world onto a sheet of sketching paper.

Talbot had just been elected to Parliament when he married in 1832, and it was not until the summer of 1833 that he was able to take his new bride, Constance, on a tour of the Continent. Autumn found them on the shores of Italy's Lake Como, and it was at Bellagio, the inspiration for so many British intellectuals, that they met up with other members of his family, including Caroline. At some point in early October, Talbot's frustrations with the pencil came to a head. While Constance and Caroline were happily sketching, he turned to the camera lucida, a device that consisted of a little prism mounted on a stem. An artist looking through it would see the scene in front of him or her apparently superimposed on the drawing paper, allowing the image to be copied by hand. But Talbot was no artist. Even with this help of science, he "found that the faithless pencil had only left traces on the paper melancholy to behold," as he later wrote in *The Pencil of Nature*.

On this occasion, whatever the muse, Talbot's failure with the camera lucida led him to recall his earlier work with the camera obscura, a drawing box that projected an image just like that within a modern camera. He reasoned that the variations of light and shade within it represented different amounts of energy. He knew that the sun could affect physical materials; if his tan did not suggest this, his extensive work in botany certainly would have. If he could harness these varying levels of energy and then make their effects permanent, nature would become his drawing mistress. And thus was the concept of photography born.

On his return to England, Talbot was immediately caught up in matters of Parliament and in bringing some mathematical work to publication. Sometime in the spring of 1834, with sunnier weather returning to his home of Lacock Abbey in Wiltshire (see p. 9), he began to convert his musings at Lake Como into an art. He rapidly homed in on silver salts as being exquisitely sensitive to light. He formed silver chloride by first washing a sheet of common writing paper with table salt and then brushing on silver nitrate. When dried, this paper would darken in sunlight. Finding its sensitivity inadequate for the camera, he positioned such objects

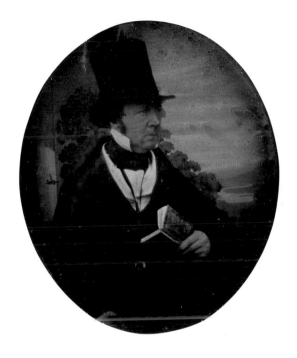

Antoine-François-Jean Claudet.
Portrait of William Henry Fox Talbot, 1846. Sixth-plate daguerreotype,
8.3 × 7 cm (3¼ × 2¾ in.). Lacock Abbey Collection, Fox Talbot Museum,
Lacock, Wiltshire, FTM 00860.

as leaves and lace on the paper and placed it directly in sunshine, where it would darken, leaving a negative shadow of the objects. In doing this, Talbot had unknowingly progressed no further than other experimenters before him. The paper remained sensitive, so the image could only be viewed under candlelight. Soon, however, his keen sense of observation noted differences in the way the hand-coated paper reacted to light. He turned this to his advantage, sensitizing the paper with a weak solution of salt and then preserving the resultant picture with a stronger solution of salt or potassium iodide. By the autumn of 1834 he had achieved lasting likenesses. In the summer of 1835 he perfected this sensitivity to the point where his paper was effective in a camera. He also realized that his negatives had the potential to make subsequent prints. Every essential element of photography as we know it was now in place. Privately, Talbot called this new process "sciagraphy," the art of depicting objects through their shadows. He did not reveal it to the public, however, turning instead to other scientific and political endeavors. This was to prove to be a heartbreaking mistake.

In early January 1839 the Parisian showman and artist Louis Jacques Mandé Daguerre announced that he had found a way to capture the images of the camera obscura. Not knowing what his rival had accomplished, Talbot rushed to bring his invention before the public. On January 25 his photographs were exhibited before a large audience at the Royal Institution in London, and on January 31 his paper on the new "art of photogenic drawing" was presented to the Royal Society. But it was too late. Although Daguerre's process was eventually to prove to be a beautiful but impractical bypath in the evolution of photography, its stunning images, formed on nonreproducible plates of precious silver, captured the imagination of the public. It was not until the spring of 1840 that Talbot finally began to regain ground. The experience of immediately seeing what the camera had placed on a sheet of paper began to train his eye. He began to grow as an artist, the first in photography and the first to have been trained by photography. By the summer of 1840 he had triumphantly overcome the artistic deficiencies that had caused him to invent the art initially.

Talbot's photogenic drawing was what is known as a printing-out process. All of the energy that would form the image in silver had to come from the sun; the picture actually revealed itself in the contact printing frame or the camera, without

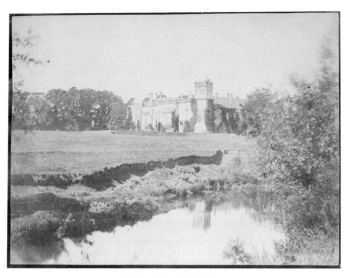

William Henry Fox Talbot.
Lacock Abbey in Wiltshire, about 1844. Salt print from a calotype negative,
image: 15.7 × 20.3 cm (6 3/16 × 8 in.); sheet: 16 × 20.7 cm (6 3/16 × 8 1/8 in.).
84.XO.968.119.

any subsequent processing. As a consequence, exposure times were long, from tens of minutes to hours. In late September 1840 he overcame this problem. Whereas photogenic drawing was something he consciously set out to invent, his subsequent process was something he discovered through astute observation. Analyzing some anomalous behavior in certain of his sensitive papers, Talbot quickly isolated an astonishing property. By adding gallic acid to his sensitizing solutions, he found that a very short exposure to light formed a latent image. The physical matter had been affected, but not in a visible way. Then, using a developing solution, he amplified this latent image into one of full strength. A short exposure in the camera, lasting only seconds, yielded a photograph that could be developed. This calotype negative process (as the inventor called it; his friends wanted to rename it the Talbotype) was so sensitive that portraits and scenes of activity could now be photographed. By 1841 he had a sensitive negative process that allowed him to print multiple times on his original photogenic drawing paper.

In a very short period Talbot and his associates created the first works of art in photography. He made thousands of images of the natural world, portraits, and records of architecture and the social structure changing around him. In 1844 he began to release *The Pencil of Nature,* the first commercially issued book to be illustrated with photographs. This contributed to his undoing, however, for the primitive plates began to fade, undermining confidence in the art.

Talbot's mother died in 1846, and his own health deteriorated rapidly. Little more than a decade after inventing the art, he gave it up. The story has a happy ending, though. Among his other activities in the 1850s, Talbot worked assiduously on the invention and perfection of what we now know as photogravure. This translation of photographs into printer's ink was the final link between photography and the printed page. His art was complete before he died.

By far the largest Talbot collection is that of the National Museum of Photography, Film & Television in Bradford, England. Combining the former Talbot holdings of the Science Museum (London), the Kodak Museum (Harrow), and the Royal Photographic Society (Bath), it is complemented by other significant public and private groupings throughout the world. The Getty Museum's Talbot collection is unique among these. The approximately 350 items that currently compose it were not selected by the vagaries of the marketplace, nor the good intentions of bequests, nor the eye of a single curator. Its real strength derives from its synthetic nature, for it gathers together the diverse visions and business acumen of several individual major collectors, each with his own point of view and his own moments of inspiration and luck in acquisition. The perspectives of André Jammes, Bruno Bischofberger, Arnold Crane, Samuel Wagstaff, Jr., and Daniel Wolf are chief among these. Together they preserved a truly outstanding record of the earliest days of an art.

Larry J. Schaaf

Plates

Note to the Reader

The plates have been printed in full color in order to convey the subtleties of tonality and the wide-ranging hues of Talbot's originals. This variety stems from a host of reasons, some well understood, others mysteries to both Talbot and to subsequent scholars. Differences in chemistry, the composition of the paper and mounts, the effects of light, and various environmental factors, starting with the coal smoke-laden air of Talbot's day and continuing with our present petrochemicals, have all played their role in writing the visual biographies of the artifacts.

Dimensions are provided for each image and for sheets and plates where applicable. Most photographs are shown full sheet, providing the context of the chemical washes, inscriptions, croppings, etc.

PLATE I

Leguminosæ
Papilionaceæ
(Pea Bean)

February 6, most likely 1836

Photogenic drawing negative
19 × 11.4 cm
(7 7/16 × 4 1/2 in.)
84.XM.1002.27

Of the thousands of Talbot images that have survived to this day, only a handful can be proven to have been made before photography became public in 1839. This ghost of a long-dead plant is one of the most extraordinary examples. Talbot inscribed the picture with the month and day that this specimen was recorded, and the year can be established almost certainly by a fully dated companion negative in the National Museum of Photography, Film & Television in Bradford, England. The delicacy of the fresh plant would have existed for only a few hours after it was picked, yet Talbot preserved its shadow for us to marvel at almost two centuries later.

In his 1839 *Some Account of the Art of Photogenic Drawing* Talbot explained that "the first kind of objects which I attempted to copy by this process were flowers & leaves, either fresh or selected from my herbarium. These it renders with the utmost truth & fidelity—exhibiting even the venation of the leaves. . . . It is so natural to associate the idea of <u>labour</u> with great complexity and elaborate detail of execution; that one is more struck at seeing the thousand florets of an <u>Agrostis</u> depicted with all its capillary branchlets . . . than one is by the picture of the large and simple leaf of an oak or a chestnut. But in truth the difficulty is in both cases the same. The one of these takes no more time to execute than the other: for the object which would take the most skilful artist days or weeks of labour to trace or to copy is effected by the boundless powers of natural chemistry in the space of a few seconds."

PLATE 2

The Roofline
of Lacock Abbey

Possibly 1838;
most likely 1835–39

Photogenic drawing negative
11.2 × 11.9 cm
(4⅜ × 4¹¹⁄₁₆ in.)
84.XM.478.9

In *Some Account of the Art of Photogenic Drawing* Talbot wrote that "perhaps the most curious application of this art is. . . . that which has appeared the most surprising to those who have examined my collection of pictures formed by solar light": the capture of "the vivid picture of external nature" displayed in the camera obscura. He had at first tried a box of conventional size, large enough to hold a sheet of sketching paper, but "a little experience in this branch of the art showed me that with smaller camera obscuræ the effect would be produced in a smaller time. Accordingly I had several small boxes made, in which I fixed lenses of shorter focus, & with these I obtained very perfect but extremely small pictures; such as without great stretch of imagination might be supposed to be the work of some Lilli-putian artist. They require indeed examination with a lens to discover all their minutiæ."

These pioneering photographic cameras were hardly more than crudely built wooden boxes, about the size of an apple. But magic emerged from these little contraptions. At the time unaware of the earlier work of Joseph-Nicéphore Niépce, the French physicist who created a photograph of his home in 1827, Talbot boasted: "I made in this way a great number of representations of my house in the country, which is well suited to the purpose, from its ancient & remarkable architecture. And this building I believe to be the first that was ever yet known to have drawn its own picture."

14

PLATE 3

Erica Mutabilis

March 1839

Photogenic drawing negative
14 × 6.9 cm
(5 ½ × 2 ¹¹/₁₆ in.)
84.XM.150.13

In a letter written on March 21, 1839, to his friend Sir John Herschel, the noted astronomer, Talbot wrote, "I send you a flower of heath," enclosing a negative dated March 1839 that was made from this same botanical specimen. Since the plant would have remained fresh for only a few hours, the present image was undoubtedly created on the same day (only a single leaf dropped off between the making of Herschel's negative [Museum of the History of Science, Oxford] and the production of this one). The subject was chosen carefully with its recipient in mind. Right after Talbot's 1833 conception of the idea of photography, Herschel had departed for the Cape of Good Hope. More than six hundred varieties of *Erica* flourish there, and some of these became subjects for his camera lucida drawings. He returned to England in 1838, just months before Talbot's new art was made public; his isolation in remote South Africa during the mid-1830s explains why Talbot did not discuss photography with him earlier. In January 1839, though, Herschel was one of the first people with whom Talbot shared details of his research.

Herschel, a prolific photographic inventor himself, was a critical source of support and inspiration for Talbot in the early years of the medium. This picture was one of many the two scientists exchanged. On receiving his copy of this plant, Herschel immediately thanked Talbot for "the very pretty specimen of the heath."

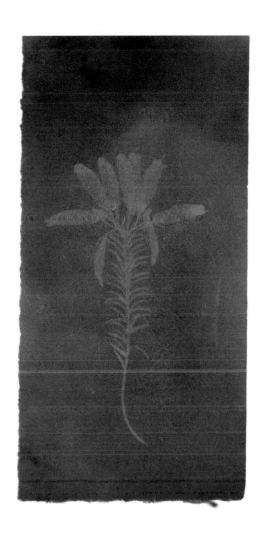

PLATE 4

Asplenium Halleri,
Grande Chartreuse 1821
—Cardamine Pratensis

April 1839

Photogenic drawing negative
20.5 × 17 cm
(8 ¹/₁₆ × 6 ¹¹/₁₆ in.)
84.XM.893.2

The announcement of photography in the dark depths of winter severely hampered Talbot's efforts to create examples of his new invention. Light, the very currency of the medium, remained precious in the spring of 1839, but some sunny moments in April finally permitted the production of additional works, such as this splendid image. In keeping with his newly public profile, Talbot proudly and thoroughly titled, signed, and dated this negative in ink before sending it to his aunt Louisa, the marchioness of Lansdowne. The powerful connections of Talbot's widespread family assisted him greatly in his publicity. Among the influential persons his aunt surely showed this to would have been her friend Sir Augustus Callcott, a marine painter who took an early interest in photography.

The plant specimens used to make this negative had a special resonance for Talbot and were probably drawn from his own hothouse. In the summer of 1821, having obtained his majority and completed his exams at Cambridge, he had set out for a natural history tour of Switzerland, France, and Italy. In July he wrote to his mother that "I have filled my herbarium so full . . . that I have hardly room for anything else." The following year he received a letter from William Jackson Hooker, the professor of botany at the University of Glasgow, commenting that the plant Talbot sent "from La grande Chartreuse & Grenoble, marked '<u>Asplenium</u>', is the <u>Aspidium Halleri</u>." It must have been the descendants of that 1821 specimen that Talbot now preserved by photography. However, it appears that by the time Talbot titled this example he had partially confused Hooker's expert advice.

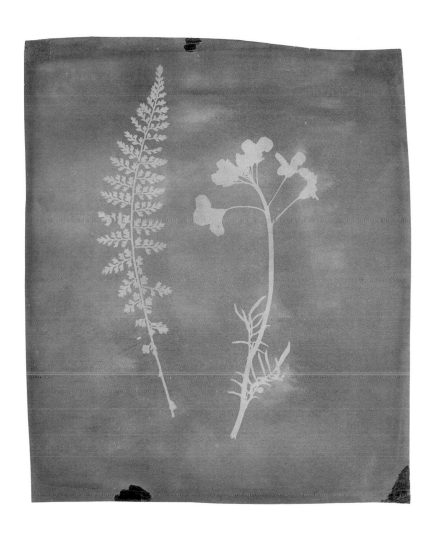

PLATE 5

Leaves of Orchidea

April 1839

Photogenic drawing negative
17.2 × 20.9 cm
(6¾ × 8³⁄₁₆ in.)
86.XM.621

In describing the production of a work like *Leaf of a Plant* in his *Pencil of Nature,* Talbot explained that a delicate leaf "is laid flat upon a sheet of prepared paper" and "then covered with a glass, which is pressed down tight upon it by means of screws. This done, it is placed in the sunshine for a few minutes, until the exposed parts of the paper have turned dark brown or nearly black. . . . The leaves of plants thus represented in white upon a dark background, make very pleasing pictures." "Very pleasing" woefully understates the active beauty of this arresting image. One's imagination can easily transform it into a gossamer-winged insect flying up to a plant. The skeletal forms yield an x-ray vision of the specimens' interior structure.

In addition to the title, Talbot signed and dated this negative in ink on the verso, most likely with presentation in mind. Its early provenance is unknown, but he recorded in his memoranda book that on April 14, 1839, he sent a photograph of an "orchis leaf" to the famous horticulturist John Lindley, a fellow botanist whom he had known for years. If this indeed was a present to Lindley, it was of a subject carefully selected by Talbot, for orchids were Lindley's particular area of study.

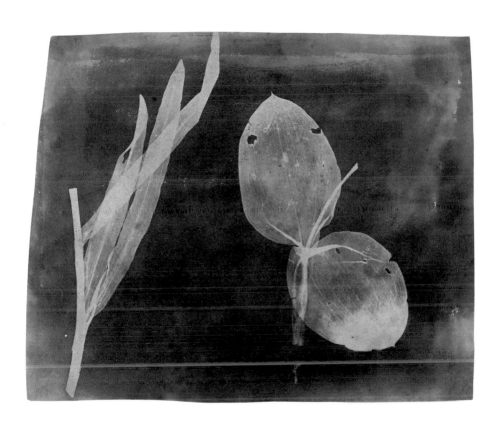

PLATE 6

Two Hawthorn Leaves and a Fig Leaf

1839

Photogenic drawing negative

17 × 19.8 cm

(6 11/$_{16}$ × 7 13/$_{16}$ in.)

86.XM.610

The naive simplicity of this image is one of its attractions today. It is a straightforward rendering of three artifacts of nature, contrasting the size and outline of the leaves within the confines of a sheet of writing paper. By February 1839 Talbot had freely published the manipulatory details of his process, which of course encouraged the curious to try it for themselves, often using the same subjects and types of paper that he employed. In later years, as firsthand memories faded and were lost, it became common to attribute any early paper photograph to him.

This negative must have had now-unknown companions, for it is mounted on a sheet of album paper cryptically titled in an unidentified nineteenth-century hand "4 photographs by Mr Fox Talbot." That in itself would not constitute proof of authorship, but this example was also signed and dated in ink on the verso by him. It almost certainly represents a presentation piece he made up for someone.

One of Talbot's largest difficulties throughout 1839 remained the production and distribution of enough examples so that people could more readily understand what he had invented. The exceptionally poor weather that year limited the number of pictures that could be produced, and those that were accomplished passed through many hands and were repeatedly exposed to daylight. In spite of all his efforts in that first public year of photography, surviving examples from it are relatively scarce.

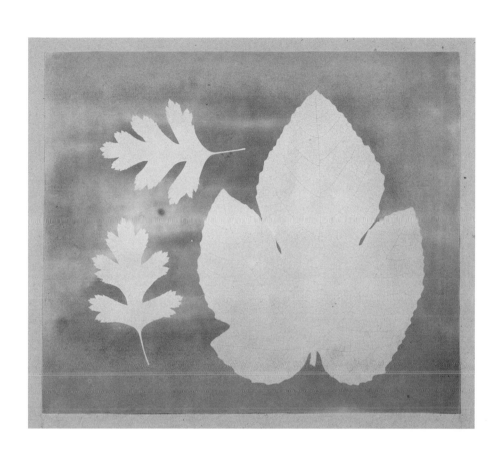

PLATE 7

Buckler Fern

1839

Photogenic drawing negative
22.1 × 17.7 cm
(8¹¹⁄₁₆ × 6¹⁵⁄₁₆ in.)
84.XZ.574.107

One of Talbot's few really close friends out-side his family was the Scottish journalist and scientist Sir David Brewster. The two men, initially drawn together by mutual interests in light and optics, were truly comfortable with each other in a way that eluded them with most of their colleagues. Brewster was among the first to hear of Talbot's new art and immediately became one of its strongest supporters. Perhaps with the help and encouragement of his wife or daughter, he compiled what was to become one of the major resources in the early history of pho-tography: the Brewster Album. Now in the collection of the Getty Museum, it brings together the pioneering work of Talbot, Brewster, and his various acquaintances in Scotland, including David Octavius Hill and Robert Adamson.

This picture, signed and dated by Talbot in ink on the verso, was one of the first photographs that Brewster ever saw. It is part of a group that Talbot made in a feverish attempt to get examples distrib-uted to important people in 1839 and must have been created on a rare day that year when the sunlight remained strong. The same exact fern specimen was used by Talbot to make at least six negatives; in two of them, obviously produced after this one, a branch dropped off in the handling.

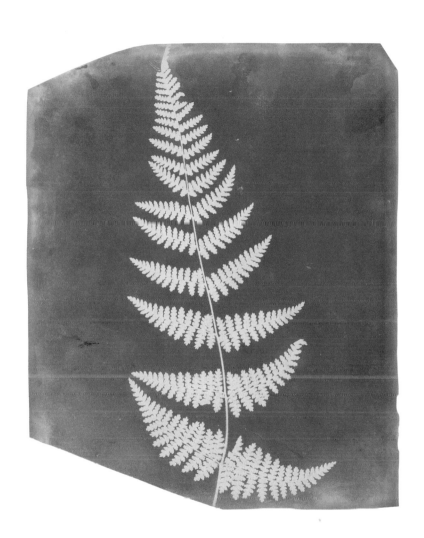

PLATE 8

Roofline of Margam Castle, the Home of C. R. M. Talbot

Most likely December 1839

Salt print from a
photogenic drawing negative
Image: 10 × 10.9 cm
(3¹⁵⁄₁₆ × 4¼ in.)
Sheet: 10.3 × 17.3 cm
(4¹⁄₁₆ × 6¹³⁄₁₆ in.)
85.XM.150.11

At the end of 1839 Talbot went to visit the newly built estate of his Welsh cousin, Christopher Rice Mansel "Kit" Talbot, who was known as the wealthiest commoner in all of Britain. While there, he began practicing an activity that he had speculated on in *Some Account of the Art of Photogenic Drawing* at the very beginning of that momentous year: "To the traveller in distant lands, who is ignorant, as too many unfortunately are, of the art of drawing, this little invention may prove of real service. And even to the artist himself, however skilful he may be. For, although this natural process does not produce an effect much resembling the productions of his pencil, & therefore cannot be considered as capable of replacing them, yet it is to be recollected that he may often be so situated as to be able to devote only a single hour to the delineation of some very interesting locality. Now, since nothing prevents him from simultaneously disposing, in different positions, any number of these little cameræ, it is evident that their collective results, when examined afterwards, may furnish him with a large body of interesting memorials, & with numerous details which he had not had himself time either to note down or to delineate."

The unusual trapezoidal shape of this image was a response to Talbot's need to tilt the camera upward. In order to hide the resulting pyramidal form, he trimmed the negative, which still survives, to the present contours, keeping the sides of the paper parallel to the lines of the building.

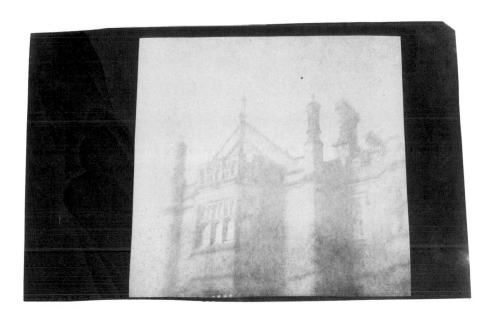

PLATE 9

Lace — A Test of
Sunlight Exposure
December 1839

Photogenic drawing negative
9.5 × 8.8 cm
(3¾ × 3⁷⁄₁₆ in.)
84.XM.1002.29

Talbot triumphantly inscribed on the verso of this negative "Exposed to the light for a month Decʳ 1839." In *Some Account of the Art of Photogenic Drawing* he had explained that "the nitrate of silver, which has become black by the action of light, is no longer the same chemical substance that it was before. Consequently, if a picture produced by solar light is subjected afterwards to any chemical process, the white & dark parts of it will be differently acted upon." It was this difference that Talbot exploited by using a fixer (in this case potassium bromide) to make the image permanent. Even in January 1839 he could show the members of the Royal Society that "this chemical change, which I call the <u>preserving process</u>, is far more effectual than could have been anticipated.

The paper, which had previously been so sensitive to light, becomes completely insensible to it, insomuch that I am able to show the Society specimens which have been exposed for an hour to the full summer sun, & from which exposure the image has suffered nothing, but retains its perfect whiteness." By the end of the year that hour of torture had been extended to a full month. In spite of this early negative's prolonged baptism in sunlight, it survives in remarkable condition.

PLATE 10

The China Bridge
over the River Avon
at Lacock Abbey
April 3, 1840

Photogenic drawing negative
16.6 × 21.3 cm
(6½ × 8⅜ in.)
84.XM.1002.7

In the earliest days of photography, before cameras became standardized articles of commerce, Talbot produced his negatives in an arbitrary variety of sizes and proportions. Since they were made on plain paper, cropping them to a shape appropriate to the image was not unusual. Trimming was also sometimes used to remove chemical or optical defects. To our modern eyes, accustomed to the regularity of factory-made snapshots, it is difficult to imagine the reasons for the extensive and almost fanciful cutting of the present work. It is tempting to think that samples were removed by some subsequent researcher for test purposes, but evidence shows that the trimming must have been done early on, perhaps as soon as the picture was processed. The print Talbot made from this negative (Bibliothèque Nationale, Paris) was immediately dispatched to Sir John Herschel, and it shows this same outline. Talbot must have wanted to excise large areas of defects or undesired details and did so seemingly oblivious to the extraordinary geometrical shape the negative was assuming.

The River Avon still runs its tranquil course around Lacock Abbey, much the same as in the scene Talbot depicted. The bridge is now gone, but its footings continue to serve the needs of local fishermen.

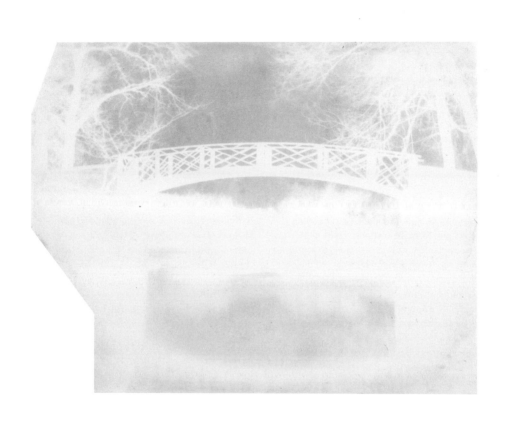

PLATE 11

Wall in Melon Ground, Lacock Abbey

May 2, 1840

Photogenic drawing negative
17.2 × 21.2 cm
(6¾ × 8⁵⁄₁₆ in.)
84.XM.260.6

PLATE 12

Wall in Melon Ground, Lacock Abbey

May 2, 1840

Salt print from a
photogenic drawing negative
Image: 16.9 × 21.4 cm
(6⅝ × 8⁷⁄₁₆ in.)
Sheet: 17.2 × 21.7 cm
(6¾ × 8⁹⁄₁₆ in.)
84.XZ.574.104

The ability of photographs to transcend time, one of their most marvelous aspects, is also one of their most deceptive. They bring to us scenes of yesteryear, but we interpret those scenes with the eyes of today. For example, the dry stone wall that forms the critical backdrop of this negative (pl. 11) and print (pl. 12) appears ancient to us now, and it certainly was built in a manner familiar to many generations at Lacock Abbey. However, it might well have had a different meaning for Talbot, one representing change and modernity. In 1833, the same year in which Talbot first conceived of the idea of photography, his stepfather, Captain Charles Feilding, was supervising the extensive changes being made to the grounds of the estate. Many of these were inspired by Talbot's mother's newly revived interest in the old abbey. Stones were cast from the backyard to the melon ground and were

put to use to make a wall "to hide the frames & dung heaps from the avenue," as Talbot described in a letter from 1833. It was this freshly built structure that was to catch his eye a few years later.

Whether he constructed this scene or merely came upon it, Talbot's growing artistic sense is clearly seen in the arrangement of the tools. The pyramid formed by their handles creates a powerful core for the image, and the dimensionality is heightened by the strong gleam off of the shovel's blade. Increasingly conscious of the public audience he might reach, Talbot inscribed the negative "Scene at Lacock H. F. Talbot 1840" and sent it to Sir David Brewster. Obviously proud of the picture, Talbot also promptly sent copies to Sir John Herschel (Bibliothèque Nationale, Paris) and to the Italian botanist Antonio Bertoloni (Metropolitan Museum of Art, New York).

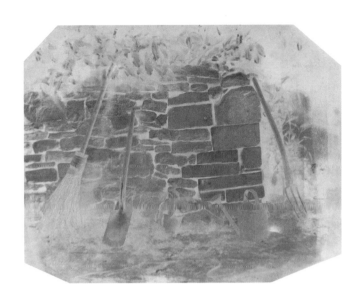

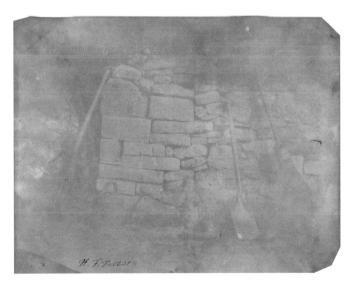

PLATE 13

Arrangement of
Six Leaves
(Sunlight Test of Fixing)

May 3, 1840

Photogenic drawing negative

22.6 × 18.3 cm

(8⅞ × 7³⁄₁₆ in.)

85.XM.150.9

Made just a day after his aesthetically pow-
erful *Wall in Melon Ground, Lacock Abbey*
(pls. 11–12), this piece represents a return
to the experimental Talbot. He dated the
negative on the verso and inscribed it "W,
long in Sun." This series of experiments
was recorded in his *Notebook P*: "Best paper
for impressions of leaves, &c. Take W. paper
wash it with weak Amm. Nitr. Silv. Dry
it at yᵉ [the] fire. Photograph the leaves for
3 minutes, then fix with iodine, & put in
very hot water. The <u>ground</u> of these pictures
remains black after very long exposure to
sunshine." The "W. paper" was Talbot's
Waterloo paper (a name he never used in
public, but one that must have given him
private satisfaction in his battle with
Daguerre); the sensitizing chemical was the
ammonio-nitrate of silver, an unstable com-
pound exquisitely sensitive to light. It would
tend to produce the blackness that he
recorded in his notebook. With the combined
effects of the "very long exposure to sun-
shine" he first gave the fixed negative and
possible subsequent changes over time, this
work serves as a reminder that these early
photographs are active and changing
objects. What we see today is not necessarily
what Talbot and his peers had in front of
them.

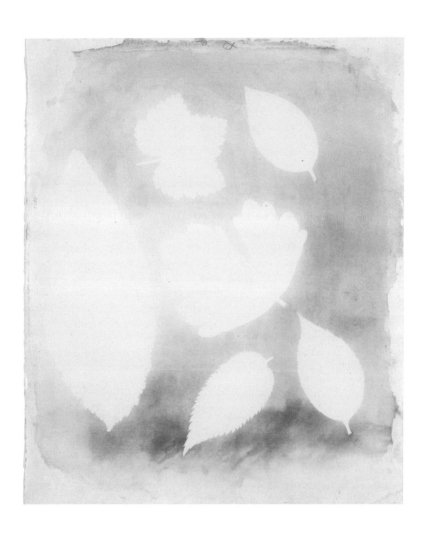

PLATE 14

Woodshed
at Lacock Abbey
1840

Photogenic drawing negative
15.4 × 19.1 cm
(6 1/16 × 7 1/2 in.)
84.XM.1002.49

The practical, day-to-day workings around Talbot's country estate provided a rich source of subject matter for his camera. As seen in pls. 11–12 and also here, the textures and patterns of farm implements played constantly with the light. The artist inscribed one of the prints made from this negative "Scene from nature. H. F. Talbot phot. 1840" and sent it to a friend, the Italian optician Giovanni Battista Amici (municipal collection of Modena).

Talbot sometimes waxed his negatives after they were processed. This made the paper base more transparent, thus facilitating printing by allowing more light through the negative to create a positive. However, this logical and seemingly practical step did not become his usual practice. Although the waxing made for faster printing when the sunshine was copious and allowed production during the frequent days when the English sky was overcast, it altered the apparent contrast as well, which was sometimes devastating to shadow detail. The waxing also embrittled the paper fibers, increasing the risk of damage to the delicate negative when it was repeatedly subjected to the rigors of printing. Several positives were made from this negative before it was cut to its present size; perhaps the subsequent trimming was done as a result of damage to the edges of the waxed paper negative.

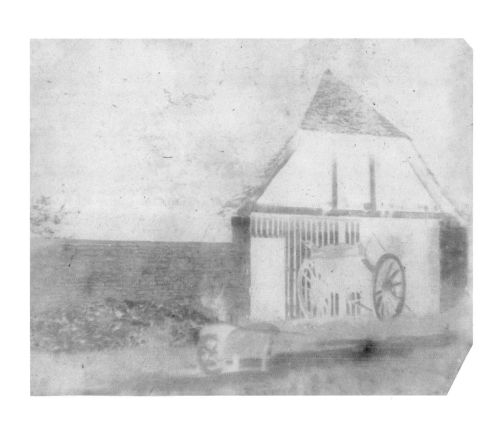

PLATE 15

Sharington's Tower
at Lacock Abbey
Most likely 1840

Paper negative
20.8 × 19.2 cm
(8³/₁₆ × 7⁹/₁₆ in.)
84.XM.1002.35

In *The Pencil of Nature* Talbot wrote that
"the Author's country seat in Wiltshire . . .
is a religious structure of great antiquity,
erected early in the thirteenth century,
many parts of which are still remaining in
excellent preservation. . . . The tower which
occupies the South-eastern corner of the
building is believed to be of Queen Elizabeth's
time, but the lower portion of it is much
older, and coeval with the first foundation
of the abbey. In my first account of 'The Art
of Photogenic Drawing,' read to the Royal
Society in January, 1839, I mentioned this
building as being the first 'that was ever yet
known to have drawn its own picture.' It was
in the summer of 1835 that these curious
self-representations were first obtained.
Their size was very small: indeed, they were
but miniatures, though very distinct: and

the shortest time of making them was nine
or ten minutes."

This look at Lacock Abbey reminds us
of the nature of the camera's image. A lens
naturally projects a circular picture, match-
ing its own shape, and it is only by conven-
tion that we usually trim off the edges to
form a rectangle, thus discarding much of
what the lens has seen. Here, the full field of
view is recorded on a sheet of paper too
large for this particular lens to cover com-
pletely.

The modern visitor to Lacock (now a
National Trust Village) can see most of the
abbey exactly as Talbot saw it. Although the
tower is closed to the public, it dominates
the scene.

PLATE 16

Diogenes, without Sun, 17' Exposure
October 6, 1840

Salt print from a
calotype negative
Image: 11.8 × 11 cm
(4⅝ × 4⁵⁄₁₆ in.)
Sheet: 16.3 × 15.4 cm
(6⅜ × 6¹⁄₁₆ in.)
84.XZ.574.47

Reminiscing in the last days of his life, Talbot recalled in text he was preparing for Gaston Tissandier's *History and Handbook of Photography* (1878) that "the discovery of the latent image and the mode of its development was made rather suddenly on September 20 and 21, 1840. This immediately changed my whole system of work in photography. The acceleration obtained was so great, amounting to fully *one hundred times,* that, whereas formerly it took me an hour to take a pretty large camera view of a building, the same now only took about *half a minute*; so that instead of having to watch the camera for a long period, and guard against gusts of wind and other accidents, I had now to watch it for barely a minute or so." Writing about his new calotype process contemporaneously in the *Literary Gazette* of February 13, 1841, he explained that "this increased rapidity is accompanied with an increased sharpness and distinctness in the outlines of the objects, —an effect which is very advantageous and pleasing."

This print, sent to Sir David Brewster, was inscribed on the verso in ink by Talbot "The Hall at Lacock Abbey H. F. Talbot phot: Oct. 6. 18 17' diffused daylight." It shows a wall niche with a depiction of the fourth-century B.C. philosopher Diogenes. Whereas the Greek sought truth with the aid of the light from his lantern, Talbot found his truths in the capture of shadows.

PLATE 17

An Oil Painting Propped Up in the Cloisters Courtyard at Lacock Abbey

Most likely 1839–40

Salt print from a paper negative
18.5 × 23.1 cm
(7 ¼ × 9 ⅟₁₆ in.)
85.XM.150.45

In an innocent scene certain to make a modern paintings conservator shudder, an oil portrait has been pulled from the halls of Lacock Abbey and propped haphazardly out in the sunlight in order to be photographed. Although the negative is not known, this print is laterally reversed from two similar ones preserved in the Fox Talbot Museum in Lacock. Lines on the present work indicate that it may have been copied from one of these.

Talbot's informal outdoor studio at Lacock Abbey was a favorite place for him to photograph. Convenient to his workroom, the cloisters blocked some of the troublesome wind yet still let in copious rays of sunshine. In *The Pencil of Nature* he wrote that "the cloisters. . . . are the most perfect which remain in any private residence in England. By moonlight, especially, their effect is very picturesque and solemn. Here, I presume, the holy sisterhood often paced in silent meditation; though, in truth, they have left but few records to posterity to tell us how they lived and died. The 'liber de Lacock' is supposed to have perished in the fire of the Cottonian library. What it contained I know not—perhaps their private memoirs." Had Talbot's invention of photography been available centuries before, perhaps copies of these manuscripts would still survive, just as this photograph has preserved a now-lost painting.

PLATE 18

Nicolaas Henneman

Most likely April 1841

Calotype negative

6.6 × 4.6 cm

(2⁹⁄₁₆ × 1¹³⁄₁₆ in.)

85.XM.150.63

In April 1839 Talbot published in the *Literary Gazette* the prediction that "the most important application of which the new art is susceptible" is perhaps "that of taking portraits from the life with a camera obscura." He went on to say that "I have not yet accomplished this, although I see no reason to doubt its practicability." Within eighteen months he had succeeded. Writing to the *Literary Gazette* in February 1841, Talbot reported that he "made trial of it last October; and found that the experiment readily succeeded. Half-a-minute appeared to be sufficient in sunshine, and four or five minutes when a person was seated in the shade, but in the open air. After a few portraits had been made, enough to shew that it could be done without difficulty, the experiments were adjourned to a more favourable season." That season had just started when this photograph was taken.

This portrait captures the strength and resolve of Nicolaas Henneman, the Dutch-born and Parisian-trained valet at Lacock Abbey. When photography was made public, he rapidly became Talbot's most trusted assistant in the new art. Two other portrait negatives of Henneman are almost identical in size and in this very distinctive trimming. One, in the Snite Museum in Notre Dame, Indiana, is also unmarked, but the other, in the Smithsonian collection in Washington, D.C., is dated April 15, 1841. All three of these were almost certainly made at the same session.

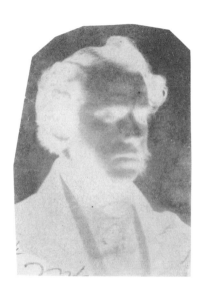

PLATE 19

Oxford, Opposite the Angel Inn

Most likely 1840–41

Salt print from a
calotype negative
Image: 13.6 × 17.1 cm
(5 5/16 × 6 3/4 in.)
Sheet: 18.3 × 18.1 cm
(7 3/16 × 7 1/8 in.)
84.XZ.574.68

Even though he was a Cambridge man, Talbot made many more trips to Oxford to photograph, the newly opened railway lines making this a much easier journey. He was rewarded with a wealth of subjects in this ancient and picturesque city. In the absence of any dating by him, it is impossible to know when this particular image was made. However, the very rare pink color of the print points toward an early date, most likely indicating a time when his chemistry was experimental. The negative and several other copies of the picture survive, but none are marked; this and one other print are on watermarked "J Whatman 1839" paper. Sir David Brewster preserved this example in his album, but whether he took note of its extraordinary color or was more intrigued by its precise rendering of the famous English city is unknown.

Talbot's subject here was a coffeehouse. Just to the left of his framing is the path to St. Peters in the East and, past that, Queen's College. The building in which Talbot placed his camera, the Angel Inn, was directly across the High Street and was one of the many coaching establishments on the road to London. The coffeehouse retains its original function to this day (with a baffling offering of variations on the basic drink), but the coaching houses were less adapted to change. The Angel Inn became the shop of Frank Cooper, the famous marmalade maker, and has since been a succession of shops catering to the booming tourist trade in Oxford.

PLATE 20

Leaves of Jasmine

Most likely April 1840–42

Photogenic drawing negative
18.8 × 11.5 cm
(7 ⅜ × 4 ½ in.)
84.XM.1002.8

Glowing as if illuminated by an internal fire, this jasmine plant speaks of light, the very thing that has preserved its image over the decades. The color is vivid and uncommon in Talbot's early work. The overlapping of some of the leaves hints at a three-dimensionality that is not actually present. The slightly brighter tones of the interior of the image heighten this sense and also serve to frame the specimen. This pattern is unusual. In-camera negatives are often lighter at the edges, where the illumination falls off, but this picture was made with the plant directly in contact with the sheet of sensitive paper. Also, when they fade, prints and negatives most often suffer first at the edges, which are more vulnerable to the atmosphere and are the most often handled part. Why is this example different?

There is a great deal we do not know and may never understand about the chemistry of these early images. The most likely explanation here comes from the fact that when a sheet of paper is washed, the chemicals tend to migrate to the edges before leaving the paper. (This is one reason why moderately older photographic prints often have colored stains in their border areas.) Perhaps a chemical beneficial to the long-term stability of the silver deposit was working its way toward the edge of this negative when the washing was stopped. The effect may not have been visible until decades later, but whatever the cause, it now makes an essential and positive contribution to the visual qualities of this picture.

PLATE 21

**Lady Elisabeth
Feilding Standing
with a Parasol**
August 21, 1841

Salt print from a
calotype negative
Image: 15.7 × 9.1 cm
(6 3/16 × 3 9/16 in.)
Sheet: 17.4 × 11.2 cm
(6 13/16 × 4 3/8 in.)
84.XZ.574.51

Of all the figures influential in the early history of photography, few can claim the role played by Lady Elisabeth, Talbot's mother. Widowed five months after Talbot was born, she married Captain Charles Feilding four years later, and together they raised Henry and his two stepsisters and rebuilt the terribly weakened family fortunes. Lady Elisabeth had burning ambitions for her son (ones he did not share!) and carefully tutored him from the start. It was from her that a fascination for languages and a love of travel were instilled. And while she was unable to transfer her own considerable attainments in aesthetic productions to him, certainly Talbot's appreciation of the fine arts was shaped by her influence. When photography became known to the public in 1839, she immediately began working with Talbot to produce examples. Her cupboards and trunks yielded subject matter, she assisted in setting up scenes, and undoubtedly her advice was freely given. Lady Elisabeth also mined her extensive social contacts to spread the word about the new medium. Talbot's stock of prints and negatives was continually depleted by her generosity, and his definition of the art was shaped by his mother, who, for example, was the driving ambition behind the production of *The Pencil of Nature.*

This portrait of Lady Elisabeth was preserved in Sir David Brewster's album. He had enjoyed his visits to Lacock Abbey immensely and had become close friends not only with Talbot but also with his mother and wife.

PLATE 22

Bust of Patroclus

September 8, 1841

Calotype negative
15.3 × 9.3 cm
(6 × 3⅝ in.)
84.XM.1002.6

PLATE 23

Bust of Patroclus

August 9, 1843

Salt print from a
calotype negative
Image: 14.7 × 14.5 cm
(5¾ × 5¹¹⁄₁₆ in.)
Sheet: 19.7 × 15.5 cm
(7¾ × 6¹⁄₁₆ in.)
84.XM.478.17

PLATE 24

Bust of Patroclus

Before February 7, 1846

Salt print from a
calotype negative
Image: 17.8 × 17.6 cm
(7 × 6¹⁵⁄₁₆ in.)
Sheet: 22.7 × 18.6 cm
(8¹⁵⁄₁₆ × 7⁵⁄₁₆ in.)
84.XP.921.2

This plaster cast was one of Talbot's most active assistants in the early days of photography. While the white material readily reflected light from any angle, facilitating exposures when the chemicals were slow, its deep sculpting was even more important, for it modulated the light in endlessly fascinating ways. The bust was also of convenient size and weight to be carried about, within and without Lacock Abbey. Talbot knew this sitter as Patroclus, the hapless but loyal defender of Achilles. Later research has revealed, however, that the cast, taken from a marble in Charles Townley's collection (still preserved in the British Museum, London), may be of a companion of Ulysses.

In *The Pencil of Nature* Talbot wrote: "Statues, busts, and other specimens of sculpture, are generally well represented by the Photographic Art. . . . since . . . a statue may be placed in any position with regard to the sun . . . causing of course an immense difference in the effect. . . . The statue may be then turned round on its pedestal, which produces a second set of variations no less considerable than the first. And when to this is added the change of size which is produced . . . by bringing the Camera Obscura nearer to the statue or removing it further off, it becomes evident how very great a number of different effects may be obtained from a single specimen of sculpture."

Talbot made dozens, if not hundreds, of images of this bust. These three show the different results he was able to achieve over the years with the help of his faithful friend.

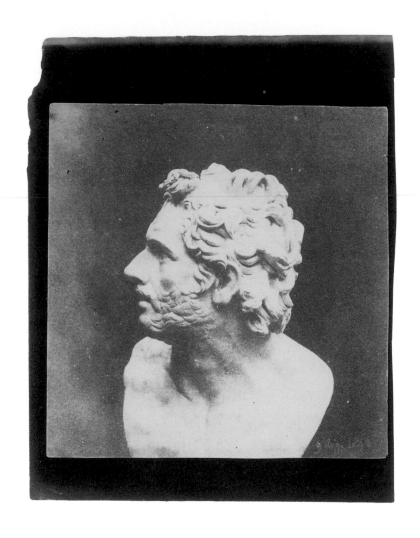

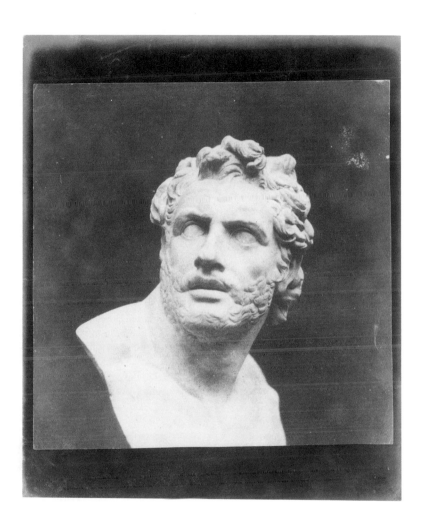

PLATE 25

Group Portrait in Front of a Backdrop

Most likely 1841–43

Calotype negative, waxed
15.9 × 17.3 cm
(6¼ × 6¹³⁄₁₆ in.)
85.XM.150.2

In *The Pencil of Nature* Talbot observed that "portraits of living persons and groups of figures form one of the most attractive subjects of photography. . . . Groups of figures take no longer time to obtain than single figures would require, since the Camera depicts them all at once, however numerous they may be: but at present we cannot well succeed in this branch of the art without some previous concert and arrangement. If we proceed to the City, and attempt to take a picture of the moving multitude, we fail, for in a small fraction of a second they change their positions so much, as to destroy the distinctness of the representation. But when a group of persons has been artistically arranged, and trained by a little practice to maintain an absolute immobility for a few seconds of time, very delightful pictures are easily obtained. I have observed that family groups are especial favourites: and the same five or six individuals may be combined in so many varying attitudes, as to give much interest and a great air of reality to a series of such pictures. What would not be the value to our English Nobility of such a record of their ancestors who lived a century ago?"

While the indistinct details and lack of annotation make the identification of the individuals in this group portrait difficult, it is possible that Nicolaas Henneman is the man on the right and that Talbot's half sister Horatia is the woman standing to the left. One of Talbot's daughters steadies herself with a hand on the knee of a seated figure, most likely her governess, Amelina Petit. A sheet of cloth haphazardly draped outside Lacock Abbey forms the backdrop.

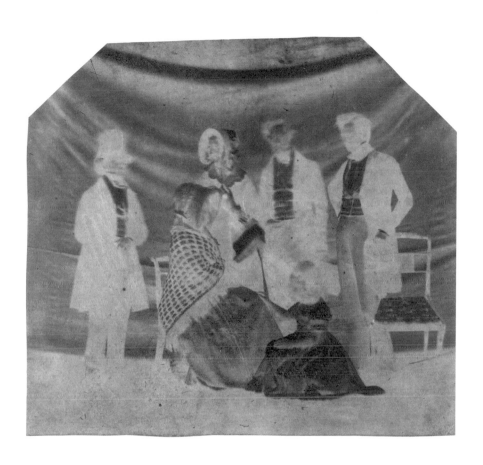

PLATE 26

Statuette of "The Rape of the Sabines"

Most likely 1841–43

Salt print from a
paper copy negative
Image: 15.3 × 9.3 cm
(6 × 3 ⅝ in.)
Sheet: 17.5 × 11.4 cm
(6 ⅞ × 4 ½ in.)
84.XZ.574.126

A complex story is hinted at by the multiple borders framing this subject, one that reveals a much different attitude toward the authorship of photographs in Talbot's day. Sir David Brewster was happy to use the power of Talbot's invention to copy one of the master's works, and Talbot would have been happy for him to do so.

This picture, from the Brewster Album, was almost certainly made by the Scotsman by copying a print supplied by Talbot. The image was itself a rendition of a reproduction, a small plaster statuette of Giambologna's famous sculpture in Florence. The outline of the original negative (National Museum of Photography, Film & Television, Bradford) is the central rectangle in Brewster's version, which is surrounded by the border of Talbot's positive. After receiving a print from Talbot, Brewster must have waxed it, placed it in contact with a sheet of sensitized paper, and then exposed the pairing to sunlight. This formed a new negative with yet another border, which in turn was placed in contact with an additional sheet of paper to make the final positive. The wrinkles from the waxed paper of the original print as well as a partial watermark (Whatman's Turkey Mill) were recorded along with the various borders.

Brewster made at least one other copy of the image this way. It is in an album (also in the Getty collection) compiled by the Maitland family, who lived near St. Andrews. The initial print that Talbot sent to Brewster is not known to have survived these trials, however.

PLATE 27

Three Pieces of Dresden China on a Round Table

July 1842

Calotype negative
8.3 × 11 cm
(3¼ × 4⁵⁄₁₆ in.)
85.XM.150.15

Writing in the *Literary Gazette* in February 1841, Talbot stated: "I remember it was said by many persons, at the time when photogenic drawing was first spoken of, that it was likely to prove injurious to art, as substituting mere mechanical labour in lieu of talent and experience. Now, so far from this being the case, I find that in this, as in most other things, there is ample room for the exercise of skill and judgment. It would hardly be believed, how different an effect is produced by a longer or shorter exposure to the light, and, also, by mere variations in the fixing process, by means of which almost any tint, cold or warm, may be thrown over the picture, and the effect of bright or gloomy weather may be imitated at pleasure. All this falls within the artist's province to combine and to regulate; and if,

in the course of these manipulations, he, *nolens volens,* becomes a chemist and an optician, I feel confident that such an alliance of science with art will prove conducive to the improvement of both."

These pieces of china were excellent subjects with which to show the modeling of form by light. Talbot's conceit of pulling the tablecloth into a severe drape makes for a more active composition, giving the impression of the effects of a gust of wind. These works, drawn from the cupboards at Lacock Abbey, were also incorporated in the photograph *Articles of China* (pl. 37).

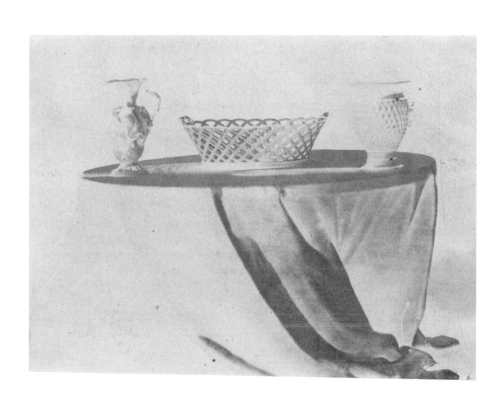

PLATE 28

High Street, Oxford

Most likely July 1842

Salt print from a
calotype negative
Image: 18.8 × 17.2 cm
(7⅜ × 6¾ in.)
Sheet: 25 × 19.8 cm
(9¹³⁄₁₆ × 7¹³⁄₁₆ in.)
84.XM.478.5

In *The Pencil of Nature* Talbot wrote of Oxford that its "ancient courts and quadrangles and cloisters look so beautiful so tranquil and so solemn at the close of a summer's evening, that the spectator almost thinks he gazes upon a city of former ages, deserted, but not in ruins: abandoned by man, but spared by Time. No other cities in Great Britain awake feelings at all similar. In other towns you hear at all times the busy hum of passing crowds, intent on traffic or on pleasure— but Oxford in the summer season seems the dwelling of the Genius of Repose."

In this image Talbot has concentrated on the commercial High Street. This general view was made famous by the accounts of visitors to Oxford. In the days before the railroad, the coach path up from London led over the Magdalen Bridge, where this active sweep was the introduction to the city. Talbot's exposure time—perhaps a minute or so—blurred any figures in the roadway; only a horse cart in the distance was recorded clearly. It is a powerful composition, the unusual framing doing full justice to so memorable a scene. The location is much the same today, but the risks in placing one's camera in this position are markedly increased. Contrary to the quiet summers that Talbot enjoyed there when the university was out of session, the summertime now is a punishing crush of sightseers. This scene can be taken only in brief segments in the intervals between giant tourist coaches.

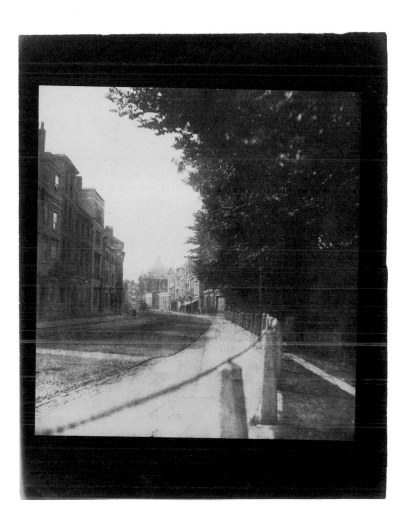

PLATE 29

Oak Tree in Winter

Most likely 1842–43

Salt print from a
calotype negative
Image: 18.5 × 16.6 cm
(7 ¼ × 6 ½ in.)
Sheet: 22.4 × 18.8 cm
(8 ¹³⁄₁₆ × 7 ⅜ in.)
84.XM.893.1

In March 1841 Talbot's childhood tutor, Dr. George Butler, was so enthusiastic about his former pupil's invention that he suggested in a letter that "what I should like to see, would be a set of photogenic Calotype drawings of Forest Trees, the Oak, Elm, Beech, &c. taken, of course, on a <u>perfectly</u> <u>calm</u> day, when there should not be one breath of wind to disturb and smear-over the outlines of the foliage. This would be the greatest stride towards effective drawing & painting that has been made for a Century. One Artist has one touch for foliage, another has another. . . . but your photogenic drawing would be a portrait; it would exhibit the <u>touch</u> of the great Artist, Nature." This is one example—and a very fine one indeed—of the skeletal forms of trees that Talbot was to photograph. He was able to get to the very structure of the tree, silhouetted against the clear light of a winter day and carefully placed in context with the trees on the horizon. A shorter exposure time permitted better sharpness by limiting the wind's effects on the branches.

Unusually, this particular print also tells another story. One can see a slight irregularity along the right edge near the top that serves as a reminder that the negative was on paper and was trimmed by hand. Other positives made from the negative record a slight stub of paper where the scissors wandered. It broke off or was removed before this example was made.

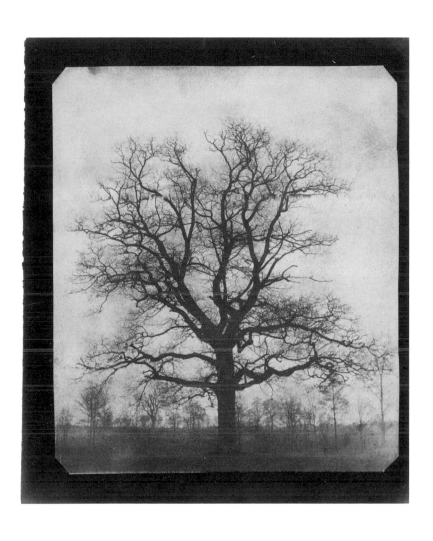

PLATE 30

Nicolaas Henneman
Holding Up a
Print in an Album
Most likely 1842–44

Salt print from a
calotype negative
Image: 14.9 × 8.2 cm
(5⅞ × 3³⁄₁₆ in.)
Sheet: 17.9 × 10.5 cm
(7¹⁄₁₆ × 4⅛ in.)
85.XM.150.56

Why this print was cut in half is a complete mystery. The negative used to make it, still whole and in a private collection, shows another man sitting across the table examining the picture that Henneman is displaying (unfortunately, not enough detail is preserved to identify it). Although most likely a page from an album, it could very well be a plate from a bound copy of *The Pencil of Nature.*

By late 1843 Henneman had gained so much confidence in the new art that he left Talbot's employ in order to start the world's first photographic printing establishment. It was at this business, located in the active commercial town of Reading, about midway between Lacock and London, that he began to turn out editions of photographic prints, including the plates for *The Pencil of Nature* and *Sun Pictures in Scotland* (1845), as well as many loose images. Some of these were purchased by Talbot himself to distribute to various people; others were sold through a network of printsellers. Here, Henneman was proudly showing off what he could produce.

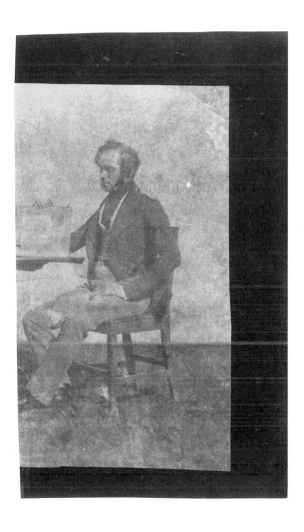

PLATE 31

Stem of Delicate Leaves of an Umbrellifer

Most likely 1843–46

Photogenic drawing negative
22.9 × 19 cm
(9 × 7⁷⁄₁₆ in.)
84.XM.1002.57

The exceptional boldness of this image conveys a visual impression that at first may seem quite unlike other of Talbot's pictures. Although the original plant was delicate, its sharply delineated white shadow on the rich dark brown background creates a graphic, two-tone effect. The same specimen was used in a slightly different orientation to make a negative that is preserved in one of the family albums at the Fox Talbot Museum in Lacock.

Other visually similar works in Talbot's oeuvre help us to understand what we are seeing here. Some of them show the interior structure of the plant specimens he photographed, proving that the negatives at first had fuller details. Because the most vulnerable sections of silver-based images are those that are light in tone, these areas will fade disproportionately faster than the darker parts. In this case, the lightest tones would have been in the interior spaces of the plant, and these at some point faded. It is unlikely that Talbot saw the same picture we see today, at least not when he first made it, but the boldness of the present state reminds us that changes over time can create as well as destroy.

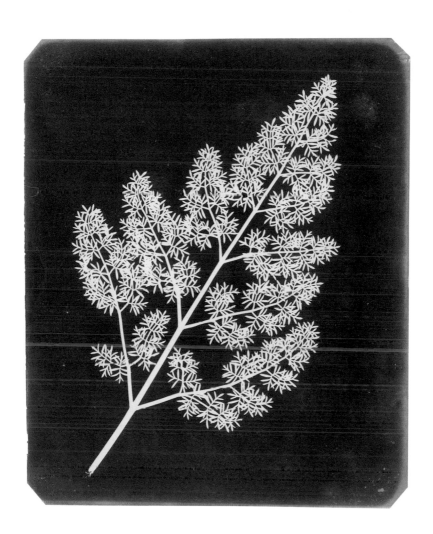

PLATE 32

Round Tower, Windsor Castle

Most likely 1841–43

Salt print from a
calotype negative
Image: 21.3 × 17 cm
(8 ³⁄₈ × 6 ¹¹⁄₁₆ in.)
Sheet: 21.8 × 17.2 cm
(8 ⁹⁄₁₆ × 6 ¾ in.)
84.XO.968.118

Talbot's half sister Caroline Mount Edgcumbe was a lady-in-waiting, and she showed the queen some of her brother's earliest productions (Victoria particularly favored the photographic renditions of ribbon). On May 6, 1841, Caroline secured written permission for Talbot to walk the grounds of Windsor Castle to make "drawings." It was almost certainly not his only visit there; this bold and unconventional view of the castle's main tower was most likely taken on a subsequent outing.

This picture is also part of an unsolved mystery. It is contained in an album of largely experimental images compiled by Hippolyte Bayard, the independent French inventor of direct-positive photography who was largely forgotten in the excitement over Daguerre. The print is mounted on the same page as another Talbot work, *Lacock Abbey in Wiltshire* (p. 9). Subsequent captions in an unrecognized hand imply that Bayard visited Talbot in England. While there is no record of direct contact, much is still not known, in spite of the existence of nearly ten thousand of Talbot's letters, numerous diaries, and various other documentary sources. However, Talbot's friend the Reverend Calvert R. Jones, a Welsh marine painter who later became an active photographer, did meet with Bayard in Paris and even worked with him. We know he took some Talbot prints to Bayard; this is probably how these examples wound up in the album. They are an intriguing connection between two inventors who shared a common dream, whether or not they ever met.

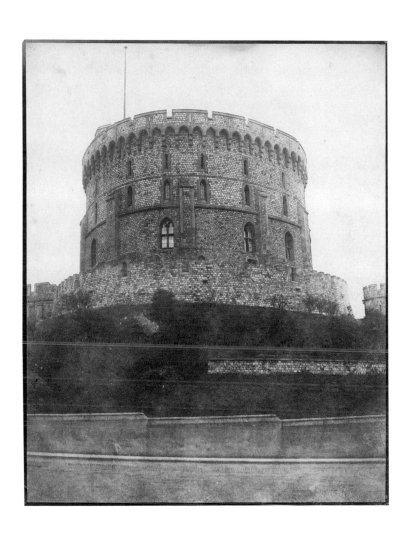

PLATE 33

The Boulevards of Paris

May 1843

Salt print from a
calotype negative
Image: 16.2 × 21.4 cm
(6⅜ × 8⁷⁄₁₆ in.)
Sheet: 18.7 × 23.2 cm
(7⅜ × 9⅛ in.)
84.XM.478.8

The fundamental virtue of the daguerreotype was seen as its perfect capture of details. In 1843 Talbot boldly ventured into the home territory of his rival, Daguerre, to prove that the calotype could do the same. He carefully selected a hotel room near the present Place de l'Opéra whose windows had a commanding view over the city. His description of this scene, the second plate in *The Pencil of Nature*, was the most complete of any in his text: "The spectator is looking to the North-east. The time is the afternoon. The sun is just quitting the range of buildings adorned with columns: its façade is already in the shade, but a single shutter standing open projects far enough forward to catch a gleam of sunshine. The weather is hot and dusty, and they have just been watering the road, which has produced two broad bands of shade upon it, which unite in the foreground, because, the road being partially under repair (as is seen from the two wheelbarrows, &c. &c.), the watering machines have been compelled to cross to the other side." Perhaps most marvelous of all to Talbot was the fact that "a whole forest of chimneys borders the horizon: for, the instrument chronicles whatever it sees, and certainly would delineate a chimney-pot or a chimney-sweeper with the same impartiality as it would the Apollo of Belvedere."

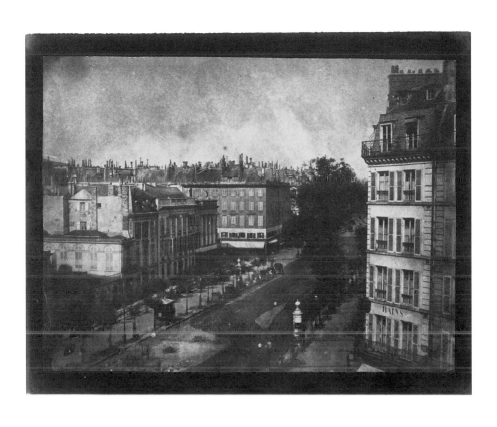

PLATE 34

**Paris Townhouses
with Carriages**
May 1843

Salt print from a
calotype negative
Image: 16.8 × 17.3 cm
(6⅝ × 6¹³⁄₁₆ in.)
Sheet: 19 × 23 cm
(7⁷⁄₁₆ × 9¹⁄₁₆ in.)
84.XM.478.6

The previous plate is a bird's-eye view of Paris. Removed and all-knowing, it safely and coolly examines the complex geometry of the city. In a remarkable change of vision on the same visit, Talbot stationed himself nearly at street level in order to take this photograph. Placing his camera in a slightly elevated position, perhaps in a hotel or shop room a floor or so above the avenue, he projects himself, and us, directly into the scene. The lamp in the foreground defines a three-dimensional space and perhaps helps to explain the unusual framing of the image. Instead of capturing all of the facade of the edifice across the street, Talbot provides a look up an alley, giving a substantial depth to the picture, all the way from the lamp in the forefront to the next rank of structures in the rear. He employed a similar technique

in some of his photographs of Oxford, adding perspective to a scene even while hemmed in by buildings.

What could have been a routine recording of a city's architecture is here expressed as a city's life. Some people must be hidden behind the shutters; others are turned into ghosts by their own bustle. The nervous movement of the horses lends an air of tension and change. Like the carriage driver, we wait to see what will happen next.

Beyond its rendering of life in Paris, this particular plate reveals Talbot's working procedures as well, emphasizing the fact that each print was made by hand on a sheet of specially coated paper. The brushing of the precious silver salts out to near the edges adds a watercolor-like individuality to this artifact.

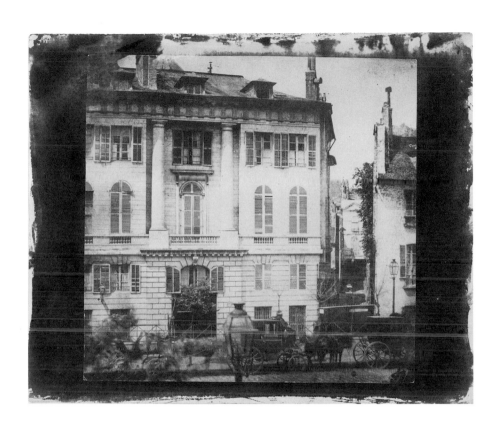

PLATE 35

Copy of a Swainson Lithographic Print of a Collared Crabeater

Most likely 1843

Salt print from a
paper negative
Image: 19.4 × 14.9 cm
(7⅝ × 5⅞ in.)
Sheet: 22.1 × 17.6 cm
(8¹¹⁄₁₆ × 6¹⁵⁄₁₆ in.)
84.XZ.574.176

In presenting *Copy of a Lithographic Print* (a Parisian caricature) in *The Pencil of Nature*, Talbot explained that "all kinds of engravings may be copied by photographic means; and this application of the art is a very important one, not only as producing in general nearly fac-simile copies, but because it enables us at pleasure to alter the scale, and to make the copies as much larger or smaller than the originals as we may desire." In *Some Account of the Art of Photogenic Drawing* he had explained that "the engraving is pressed upon the prepared paper, with its engraved side in contact with the latter. . . . The effect of the copy, though of course unlike the original, (substituting as it does lights for shadows and vice versā) yet is often very pleasing, & would I think suggest to artists useful ideas respecting light & shade. . . . but if the picture so obtained

is first <u>preserved</u> so as to bear sunshine, it may be afterwards itself employed as an object to be copied; & by means of this second process the lights & shadows are brought back to their original disposition. . . . I propose to employ this for the purpose more particularly of multiplying at small expense copies of such rare or unique engravings as it would not be worthwhile to reengrave, from the limited demand for them."

Here, Talbot made a contact copy of William Swainson's 1820 lithograph of a bird native to India. Swainson, in addition to being one of the finest zoological illustrators of his day, was actively involved in reproductive printing processes. He taught himself lithography so he could transfer his own designs directly onto the printing plate without the intervention of an engraver.

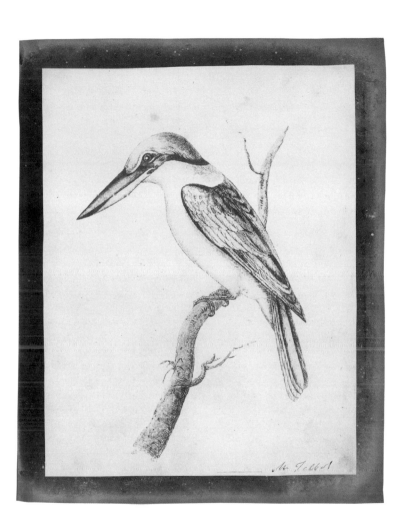

M. Tebbs

PLATE 36

PLATE 37

PLATE 38

The Milliner's Window

Before January 1844

Salt print from a
calotype negative
Image: 14.3 × 19.4 cm
(5⅝ × 7⅝ in.)
Sheet: 17.3 × 22.2 cm
(6¹³⁄₁₆ × 8¼ in.)
84.XZ.574.131

Articles of China

Before June 1844

Salt print from a
calotype negative
Image: 13.4 × 18 cm
(5¼ × 7¹⁄₁₆ in.)
84.XO.1369.3

Articles of Glass on Three Shelves

Before June 1844

Salt print from a
calotype negative
Image: 12.7 × 15.1 cm
(5 × 5¹⁵⁄₁₆ in.)
Sheet: 18.5 × 22.5 cm
(7¼ × 8⅞ in.)
84.XZ.1002.59

In *The Pencil of Nature* Talbot observed that "the whole cabinet of a Virtuoso" might be photographed, "the more strange and fantastic the forms . . . , the more advantage in having their pictures given instead of their descriptions. . . . However numerous the objects—however complicated the arrangement—the Camera depicts them all at once."

Outside Lacock Abbey, temporary shelves, draped in black velvet, supported arrangements of objects relocated from indoors, not unlike a traditional museum exhibit. Lady Elisabeth obviously delighted in this idea. She supplied the fanciful title for *The Milliner's Window* (pl. 36) and most likely the caps and bonnets as well. Did this re-create a scene from her dressing room, reconstructed outdoors in order to have sufficient light?

Two variations on this theme were published in *The Pencil of Nature*: *Articles of China* (pl. 37) and *Articles of Glass on Three Shelves* (pl. 38). The complicated surfaces of the cut glass items in the latter work create a strong visual tension with the purity and transparency of the interiors. Light is reflected and refracted simultaneously, yielding a lively complexity unknown in most photographic subjects. Somewhere hidden in those reflections—tantalizingly just beyond our perception—are multiple images of Talbot himself. This print identifies another maker in a clearer way, however. At some point when the paper was vulnerable, someone's palm rested on the surface. The skin may have transferred a chemical or simply left behind bodily oils that repelled later chemistry, but the imprint of the palm testifies to the tricky process of making each sensitive print by hand. Perhaps someday we will have the forensic tools to determine whose palm this was.

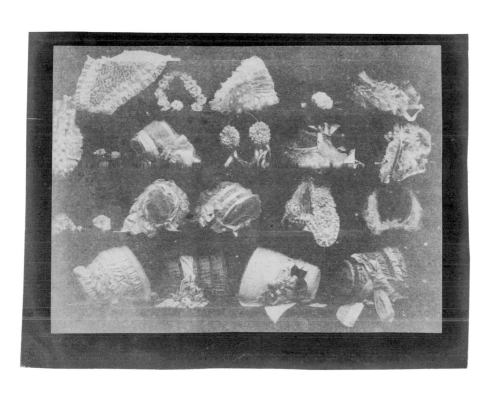

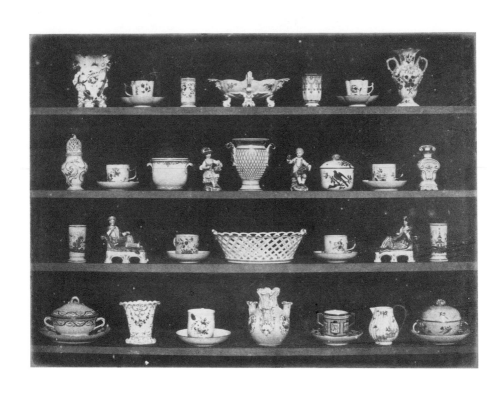

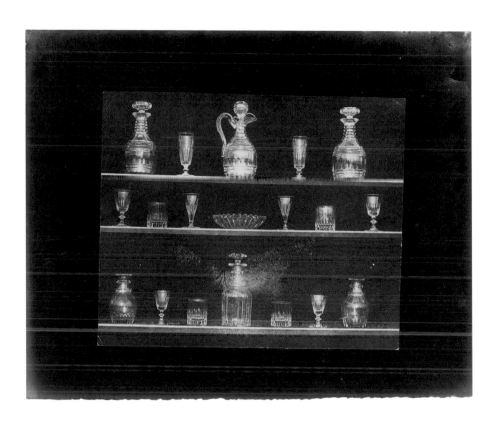

PLATE 39

Nelson's Column under Construction in Trafalgar Square, London

First week of April 1844

Salt print from a
calotype negative
Image: 17 × 21 cm
(6¹¹⁄₁₆ × 8¼ in.)
Sheet: 18.7 × 22.4 cm
(7⅜ × 8¹³⁄₁₆ in.)
84.XM.478.19

Surprised by discovering a clock face in one of his photographs of Oxford, Talbot observed in *The Pencil of Nature* that "in examining photographic pictures of a certain degree of perfection, the use of a large lens is recommended, such as elderly persons frequently employ in reading. This magnifies the objects two or three times, and often discloses a multitude of minute details, which were previously unobserved and unsuspected. It frequently happens, moreover—and this is one of the charms of photography—that the operator himself discovers on examination, perhaps long afterwards, that he has depicted many things he had no notion of at the time. Sometimes inscriptions and dates are found upon the buildings, or printed placards most irrelevant, are discovered upon their walls."

It is the printed placards secured to the hoarding surrounding the monument to Admiral Horatio Nelson, who died during his great victory at Trafalgar, that enable us to date this image precisely. Among the various playbills and railway holiday timetables is an advertisement for the Theatre Royal Lyceum. Having rescued its name from its creditors, it was opening its new season with *Open Sesame* on Easter Monday, April 8, 1844. Talbot was in London the week before meeting with a colleague, the daguerreotypist Antoine Claudet, and he must have taken this photograph during that period.

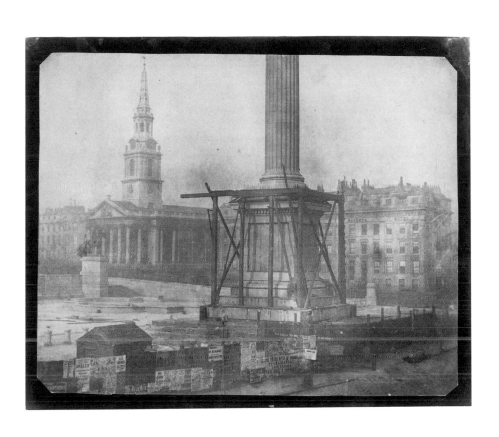

PLATE 40

The Open Door

April 1844

Salt print from a
calotype negative
14 × 18.8 cm
(5 ½ × 7 ⅜ in.)
84.XO.968.167

In describing *The Open Door*, arguably the most famous plate in *The Pencil of Nature*, Talbot wrote: "We have sufficient authority in the Dutch school of art, for taking as subjects of representation scenes of daily and familiar occurrence. A painter's eye will often be arrested where ordinary people see nothing remarkable. A casual gleam of sunshine, or a shadow thrown across his path, a time-withered oak, or a moss-covered stone may awaken a train of thoughts and feelings, and picturesque imaginings."

The "picturesque imaginings" evoked here were no mere accident. Talbot returned to this scene year after year, attempting at least four versions of it. The image is neatly divided into thirds, with alternating light and dark bands across its width; depth is added by the three planes of the broom, the doorway, and the window in the distance. The *Literary Gazette* expressed its wonder at the photograph of "a broom and a lantern, perfect in reflected form, and rich in tone of colour. A back window in the darker central tint is deliciously bright, yet dim and faithful to the reality."

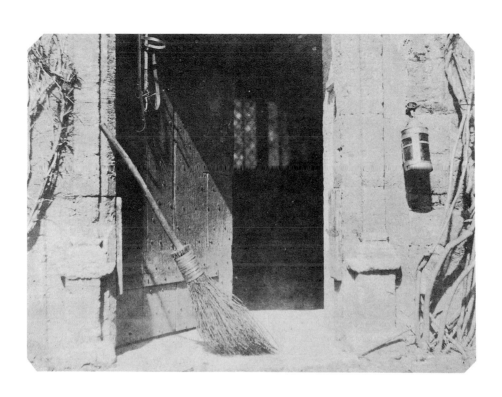

PLATE 41

Fac-simile of an
Old Printed Page
Before June 1844

Salt print from a
paper negative
16.5 × 14.2 cm
(6½ × 5⁹⁄₁₆ in.)
84.XO.1369.9

This print was mounted as the ninth plate in an original copy of *The Pencil of Nature*. The negative was "taken from a black-letter volume in the Author's library, containing the statutes of Richard the Second, written in Norman French." Talbot felt that "to the Antiquarian this application of the photographic art seems destined to be of great advantage." He cheated a little, however, by selecting for reproduction a page with text on one side only.

Talbot placed the leaf on a sensitive sheet of photographic paper in the sun. The resulting negative could then be used to make many identical copies of the original printing, an application commonplace to us today but an enormous time-saver over banks of scribes. This printed leaf was a favorite of Talbot's. It initially saw service in the summer of 1839, the first public year of photography, and he produced numerous negatives from it. The large quantity of prints required for *The Pencil of Nature* was probably made close to the time of its publication, possibly from one or more negatives freshly created for the job at hand.

Ricardi secundi

surueier le3 gort3 molyns eſtankes eſtabes ⁊ hp̉ur auncienement fai3
tes ⁊ leue3 duaunt le dit temps du Rop Edward fit3 au rop Henry
⁊ ceux qui trouerent trop enhaunt3 ou eſtret3 ⅋ le3 corriger abater ⁊ a⸗
mendr en le manere ⁊ fourme ſuiſoit3 Saluaunt tout3 foit3 reſonable
ſubſtaunce ⅋ le3 dites gort3 molyns eſtankez eſtabes ⁊ hidur ſuiſ
dites iſſint auncienement faites ⁊ leue3 Et ſi aſcuns tiels auoiſance3 de3
gort3 molyns eſtankes eſtabes ⁊ hidur de3 paſſage3 ⁊ eſtroiture3 aun⸗
cienement fait3 ⁊ leue3 ſoient adiugge3 ou aggra3 pr le3 dit3 iuſtices
deſtre abatus ⁊ amende3 cellup qui ad le fraunktenement dicell ferra
ent execucion a ſe3 coſtage3 dins vne demy an apres notificacion a lup
ent affaire ſur pepne de C mar3 a paiers au rop pr leſtret3 en leſcheqer
Et cellup qui le3 face releuer ou enhauncer ou eſtret3 encounter le dite
iugement ⁊ de ceo ſoit duement conuict encourge la pepne de C marces
apaiers au Rop per leſtret3 de leſcheqer ſuiſoit Et en cas que aſcun ſe
ſente eſtre greue3 per execucion ou autre voie en celle partie encounter
droit ⁊ remedie ℭ Ca xx ℭ Item le rop pr meſme laſſent de le3 di⸗
tes ſeignours ⁊ Chiualers enſp aſſigne3 pr la dite auctorite du perlemēt
voet ⁊ ad ordine3 que cheſcune qui pcure ou purſue de repeller ou reuer
ſer aſcuns de3 dites eſtatuites ou ordinaunces fait3 pr le rop ⅋ laſſint de3
dit3 ſeignours ⁊ chiualers iſſint aſſigne3 pr poair ⁊ auctorite du perle⸗
ment ⁊ ceo duement pͬeue en perlement que il ſoit adiugge3 ⁊ eit execu⸗
cion come traitour au rop ⁊ a roialme en meſme le manere come ceux
qi purſuont ou pcuront de repeller le3 eſtatuit3 ⁊ ordinaunces fait3 en le
temps du dit perlement duraunt

Expliciunt ſtatuta Regis Ricardi ſecundi

PLATE 42

**Effigy of Sir Walter
Scott's Favourite Dog,
Maida, at Abbotsford**
October 24, 1844

Salt print from a
calotype negative
11.5 × 16.3 cm
(4½ × 6⅜ in.)
84.XO.1004.6

In October 1844, on completing a scientific meeting in the north of England, Talbot continued on to Scotland with Nicolaas Henneman with the intention of making images for a new book. Unlike *The Pencil of Nature*, which contained a variety of photographs and was sold freely through booksellers, *Sun Pictures in Scotland* was to illustrate the wildly popular works of the late Sir Walter Scott and to be sold only by subscription. Talbot and Henneman visited the bard's home on their return journey; the exact date is known because Talbot signed the guest register, which is still preserved at Abbotsford.

Maida, a grand Scottish deerhound, was Scott's favorite dog. When the stately and aged hound died in 1824, he was buried outside the door to Abbotsford, underneath the sculpture made in his image. The Latin inscription can be translated as "O, Maida, you sleep under the stone effigy of Maida." The memorial was a practical as well as aesthetic addition, for it served as a block for mounting a horse. The statue does not stand out with the purity the photograph implies, however. In order to reduce the visual confusion, Talbot temporarily draped a piece of dark cloth behind the sculpture to keep its details from blending in with the courtyard.

After returning to England, Talbot turned the Scottish negatives over to Henneman to make prints for the book. Either Henneman or one of his assistants had some stray chemicals on his skin, for the fingerprints of the person who made this particular plate are clearly preserved.

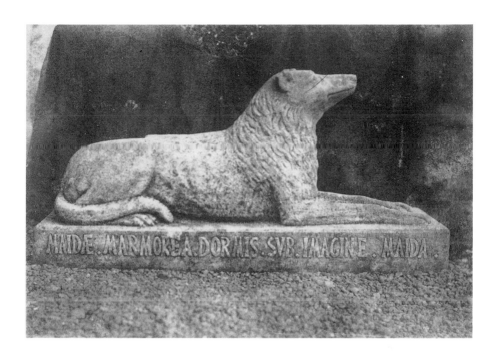

MAIDE. MARMOREA. DORMIS. SVB. IMAGINE. MAIDA.

PLATE 43

The Woodcutters

Most likely summer 1845

Salt print from a
calotype negative
15 × 20.8 cm
(5⅞ × 8³⁄₁₆ in.)
85.XM.150.5

In *The Pencil of Nature* Talbot commented that "one advantage of the discovery of the Photographic Art will be, that it will enable us to introduce into our pictures a multitude of minute details which add to the truth and reality of the representation, but which no artist would take the trouble to copy faithfully from nature. Contenting himself with a general effect, he would probably deem it beneath his genius to copy every accident of light and shade. . . . Nevertheless . . . these minutiæ . . . will sometimes be found to give an air of variety beyond expectation to the scene represented."

In this image Nicolaas Henneman and another man are posed in a re-creation of a typical scene on a country estate. The photograph gathers its "truth and reality" not only from their actions but also from the "multitude of minute details" and "acci-dent[s] of light and shade." In fact, however, the men are not captured in motion, but are carefully holding still for the duration of the exposure. Additionally, one accident of shade was eliminated. In the original negative, the gathering late afternoon shadow of Lacock Abbey presses strongly into the foreground area. After printing the negative in this state, Talbot must have decided that the shadow dominated the scene more than he wished, so he trimmed off the lower part of the negative, leading to this composition. A modern photographer would have done this cropping in the darkroom or on the computer, and with a print, not permanently with the negative. Talbot's approach with the scissors was confidently final; only the survival of an earlier print (National Museum of Photography, Film & Television, Bradford) reveals what the negative once was.

PLATE 44

The Fruit Sellers

(most likely by Calvert
R. Jones, possibly in
collaboration with Talbot)
Most likely September 9, 1845

Salt print from a
calotype negative
Image: 17.1 × 21.1 cm
(6¾ × 8⁵⁄₁₆ in.)
Sheet: 18.5 × 22.3 cm
(7¼ × 8¾ in.)
84.XM.478.7

On January 30, 1839, just days after Talbot first displayed his photographs to the public, he modestly wrote in the *Literary Gazette* that "I only claim to have based this new Art upon a secure foundation: it will be for more skilful hands than mine to rear the superstructure." In the few years between that statement and the taking of the present picture, he had grown enormously as an artist; in many ways, more skillful hands did not exist in photography. But he never lost his wish to inspire others to take the art beyond where he had. One of his first and most loyal disciples was the Reverend Calvert R. Jones.

Jones and his wife, Anne, stayed at Lacock Abbey in September 1845, and it was almost certainly during this visit that this photograph was made. As was typical of his day, Talbot saw little need to identify the particular author of a work and did so only rarely, even for himself. He purchased negatives (many from Jones), and Henneman printed these for Talbot and for sale to the public. When Henneman's business closed in the 1850s, his remaining stock of negatives and prints was returned to Talbot at Lacock Abbey. Some of these parcels remained unopened for more than a century.

Although taken at Talbot's home, stylistically this picture belongs to Jones. Some of the characters appear in other of his images from Wales. It seems logical to assume that this was the product of joint authorship, the very sort of collaboration that Talbot would have hoped for.

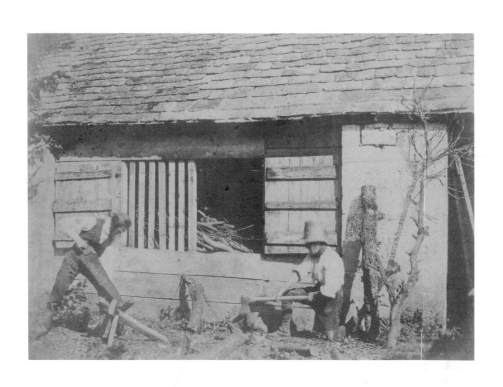

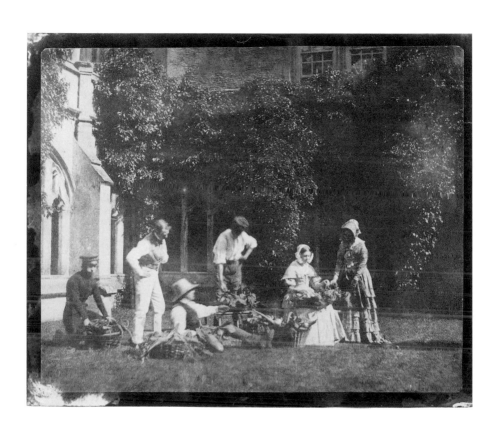

PLATE 45

Lace

Before December 1845

Photogenic drawing contact
negative
17.2 × 22 cm
(6 ¾ × 8 ⅝ in.)
84.XM.478.14

Talbot wrote in *Some Account of the Art of Photogenic Drawing* that "to give an idea of the degree of accuracy with which some objects can be imitated by this process, I need only mention one instance. Upon one occasion, having made an image of a piece of lace of an elaborate pattern, I showed it to some persons, at the distance of a few feet, with the enquiry: Whether it was a good representation? When the reply was: 'that they were not to be so easily deceived, for that it was evidently no picture, but the piece of lace itself.'"

This image is the same as the one Talbot used for the twentieth plate of *The Pencil of Nature,* but this particular example was mounted separately for sale through a printseller. Although the lace appears white, as it should, this effect is achieved because what we are viewing is a negative. A highly starched piece of lace was placed on the sensitive paper; the threads blocked the sunlight so that only the background darkened. In many ways, surrounded by camera images, this is the most primitive photograph in *The Pencil of Nature.* It may also be considered the most valuable, for every one of these "prints" is in fact a unique negative made directly in contact with the original piece of lace. It maintains a physical link with the object it depicts.

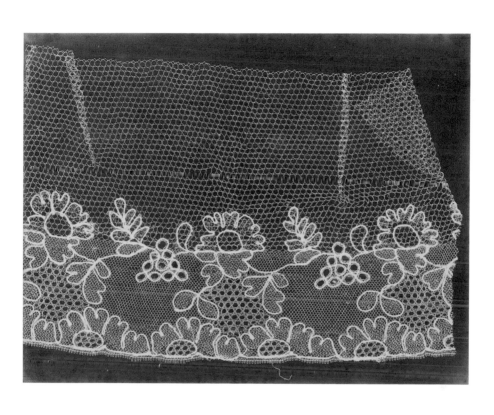

PLATE 46

Two Leafy Stalks of Bamboo
1852 or later

Photographic engraving
Image: 10.3 × 6.6 cm
(4 1/16 × 2 9/16 in.)
Sheet: 12.3 × 9.2 cm
(4 13/16 × 3 5/8 in.)
Plate: 14.3 × 11.3 cm
(5 5/8 × 4 7/16 in.)
84.XM.1002.1

Nearly two decades after he first captured the impressions of plants, Talbot returned to this familiar subject matter, but in a very different way. The art that he invented is at once as ephemeral as it is permanent. We marvel at the idea that almost two centuries later we can see the people that Talbot saw or examine the leaves that he examined or view the very rays of sunlight that he viewed. The sunshine that made the pictures, however, could team up with rogue chemicals to destroy the images as well.

Shortly after *The Pencil of Nature* started coming out, Talbot and others became aware that photographs made in silver were vulnerable to both chemicals and light. His dream of replacing conventional printing with light-made prints was punctured by the reality of their fading. By the end of the 1840s he had given up on this function for his art. However, his experiments continued along a different path, and by 1852 he was finally able to combine the hand of nature with the time-proven permanence of printer's ink. His photographic engraving process used light-sensitive chemicals to record images on copper plates, achieving the same fidelity to nature that was the strength and appeal of photography. The final works, though, were made in a printing press, using conventional inks that were based on nearly indestructible carbon. In this, Talbot had finally achieved his goal of using photography to let nature be the active guiding force of the illustrator.

PLATE 47

Rosslyn Chapel, near Edinburgh

1858 or later

Photoglyphic engraving
Image: 8.5 × 8.3 cm
(3 5/16 × 3 1/4 in.)
Sheet: 10.2 × 12.3 cm
(4 × 4 13/16 in.)
Plate: 11.6 × 12.6 cm
(4 9/16 × 4 15/16 in.)
84.XM.1002.3

In a *Literary Gazette* of March 1839, just two months after he first publicly disclosed the art of photography, Talbot confessed that the images made by the process "differed indeed from those now produced by artists." He recognized, however, that his art was young and stressed that the difference was the same "as an inferior handwriting differs from a good one—in *execution*, but not in *principle*." His earliest experiments in translating photographs into printer's ink were a primitive form of handwriting. These examples lacked the ability to carry detail over broad areas and to preserve the delicate middle tones. He kept working at this, though, and increasingly spent time around Edinburgh, the fine-printing capital of Britain. In 1858 he announced his improved photoglyphic engraving process. His printing plates were strictly photographic—no hand

retouching was involved—but he had improved their tonal range immensely. Talbot worked at this photogravure process for more than twenty-five years and was writing about it in the last days of his life. The dream he established in Italy in 1833 had been realized. Nature had become his drawing mistress.

St. Matthew's Episcopal Chapel (or Rosslyn Chapel), begun around 1450 but never completed, was the church for the college started by William Sinclair, the third earl of Orkney, about seven miles south of Edinburgh. It is noted for its decorative stone carving, which covers nearly every surface. The fantastic column on the right is the "Prentice Pillar," so called because of the apocryphal story of the apprentice who carved it, who was then murdered by the jealous master mason.

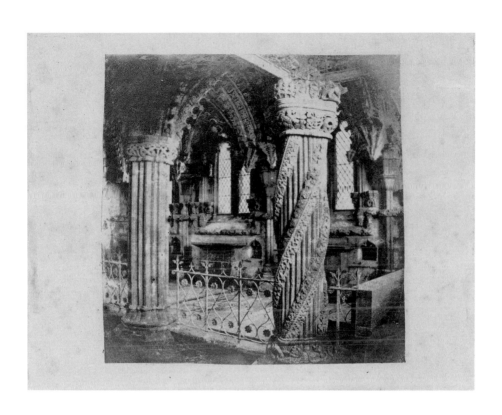

William Henry Fox Talbot.
The Pencil of Nature, 1844. Printed fascicle with mounted photographs,
30.2 × 23.8 cm (11⅞ × 9⅜ in.). 84.XZ.571.
"The plates of this work have been obtained by the mere action of Light upon sensitive paper. . . .
They are impressed by Nature's hand."

"Impressed by Nature's Hand":
The Photographs of William Henry Fox Talbot

David Featherstone: We've come together today to consider the life and work of one of the seminal figures in the history of photography: William Henry Fox Talbot. To frame our conversation, we'll be viewing a number of his images, either singly or with others, and I would invite you to use these as a springboard for your comments. To begin, I'd like to ask Larry to give us a brief biographical introduction to Talbot.

Larry J. Schaaf: The best summary I've ever encountered of Talbot was by his son, Charles Henry, after Talbot's death. He observed that his father's mind "was essentially original . . . he disliked laborious application on beaten paths." And I think Talbot's mind was essentially original He was a specialist in mathematics very early on and won a Porson Prize for his work in Greek verse. He did important research in crystallography, spectral analysis, botany, astronomy, etymology, and Assyrian cuneiform, just to mention a few of his accomplishments.

Talbot's father, William Davenport Talbot, died when his son was just a few months old. Talbot traveled with his mother, Lady Elisabeth (see p. 104), throughout the early part of his life and grew up in a succession of different homes, which perhaps explains his later wanderlust. His mother was the daughter of the second earl of Ilchester, and their relatives were all well connected. While his father drained the family fortunes, his mother rebuilt them very well. However, Talbot didn't regain control of Lacock Abbey, the ancestral home, until 1827; it had been leased out in order to pay debts.

It is fitting that our colloquium is taking place in early October, because it was in the first days of October 1833, on the shores of Lake Como, specifically at Villa Melzi in Bellagio, that Talbot first conceived of the idea of photography. He arrived at this from a need: he was unable to draw with a camera lucida and therefore tried to think of a way to let nature draw herself. He had already had a lifetime of being around artists and draftsmen and being exposed to works of art, and he was familiar with optics and a certain amount of chemistry, so all of these tools were already in him.

Sometime in the spring of 1834, after he returned to England, Talbot began to do his first real experiments with photography. He very quickly attained success with a printing-out paper. In Geneva, later that year, he conceived of the idea of what came to be known as *cliché verre*. An artist friend of his scratched a design through opaque varnish that had been coated on glass, and Talbot reproduced that drawing in multiples photographically. It was also about this time that he made his first of what we now refer to as fixing processes. By the autumn of 1834 he had achieved his initial goal of making a relatively permanent image.

During the summer of 1835, when there was glorious sunlight, Talbot created his first camera images. He very clearly understood the concept of the negative and the fact that one could make additional prints from that negative, although at this point he had no reason to since he was very pleased with the negatives themselves. Because he had already essentially accomplished what he wanted to in photography, he went on to more pressing activities in the late 1830s.

By the start of 1839, when photography received its official public announcement, Talbot was a very powerful, well-accepted, well-respected person. He had already published two books, and he would have two more come off the press shortly after that. He had published nearly thirty scientific and mathematical papers. In 1837 he had given the prestigious Bakerian Lecture at the Royal Society on his work with crystals, and in 1838 he had received the Royal Society's gold medal for his research in mathematics.

In the autumn of 1840 Talbot discovered the latent image. This led to development of the calotype and to negative-positive photography and the possibility of making multiple prints from a single negative. In 1843 his former valet, Nicolaas Henneman, established a printing business in Reading to capitalize on this advance.

H. F. Talbot [signature]

In 1852 Talbot developed the first of his photomechanical processes. In 1863 he was given an honorary doctorate of laws by the University of Edinburgh, largely in recognition of his scientific activities. In 1877, literally while he was writing a chapter on photoglyphic engraving and photogravure for Gaston Tissandier's _History and Handbook of Photography_, he died.

Weston Naef: We should address the issue of this man's proper name. I'm holding a book where he is described as Henry Fox-Talbot—hyphenated—and we know that he also had the name William.

LS: In the nineteenth century, particularly in his social group, you did not use a person's first name unless you were a relative or within a certain circle. Within the family he was almost invariably known as Henry. His uncle, William Thomas Horner Fox Strangways, was very close and traveled with the family all the time. He was known as William, and my guess is that Talbot was known as Henry just to keep the two separate.

Nobody in the family or among the people who knew him well ever called him Fox Talbot. Fox was just a middle name, and his family name was certainly not hyphenated. He didn't particularly like the name Fox, but a lot of his contemporaries used it. The situation is further confused by how he was published; we don't know what was imposed by the publisher versus what he wanted. He put H. Fox Talbot on _The Pencil of Nature_, but his concept of that book was strongly influenced by his mother, who very much liked the use of Fox as a family name.

In the hundred-plus negatives and prints I have seen that he actually signed, including dedication prints to different people or works sent to his family, the name Fox never appears. There is not a single example where he signed H. Fox Talbot. H. F. Talbot is the most common; occasionally he put W. H. F. T.

WN: So the bottom line is that he should be alphabetized under _T_.

LS: Yes, please.

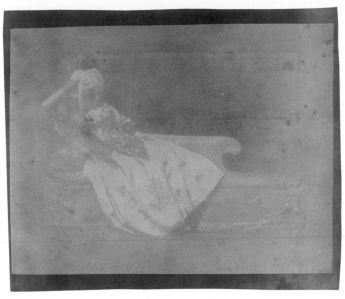

William Henry Fox Talbot.
Lady Elisabeth Feilding on Chintz Chair, April 20, 1842.
Salt print from a calotype negative, image: 12.4 × 16.4 cm (4⅞ × 6⁷⁄₁₆ in.);
sheet: 14 × 16.8 cm (5½ × 6⅝ in.). 84.XZ.574.61.

DF: Before we begin to consider Talbot's photographs, we should describe his famous publication, *The Pencil of Nature,* because I'm sure it will be mentioned frequently.

LS: Before he began to experiment with photography, Talbot had a great interest in book illustration, particularly in economical methods that could make books more widely available. He was thinking specifically of botanical works that were never published because the plates would be so expensive to engrave. He saw the potential of photography very early. He wanted to do a botanical book of a hundred plates or so, and he thought about publishing a book called *The Homes of the Poets,* in which he would show a poet's house and a sample of his or her handwriting photographically.

Talbot had these ideas percolating, and as he gained confidence in making pictures in the early 1840s, he really wanted photography to get out into the world. That's how *The Pencil of Nature* came about. By this time, Henneman had started the printing establishment in Reading, so that factory was available to turn out large quantities of prints.

The Pencil of Nature was seen as a sampler to show the potential of photography, particularly in relation to publication. It was originally envisioned as a series of fifty plates that would be issued in twelve parts. Part books were a very common means of publishing then, usually to help control the investment. Dickens published this way. The public could afford it, because if a little pocket change was available, one part could be purchased, and then by the next week if a little more pocket change was available, the next part could be purchased. In the case of *The Pencil of Nature*, the part-book structure was also necessary because every one of the prints was made by hand. It took a lot of printing to produce 250 copies.

The first part came out in June 1844. It was absolutely spectacular and got very good reviews. The second part came out just about as strongly shortly after that. Then production difficulties started to catch up with Talbot, and the weather was miserable, which was a problem because the printing process was dependent on sunshine. He started out with a tremendous burst of energy, but sales dwindled with each part, to below 100 copies by the final fascicle. His mother, one of the prime supporters of the venture, died in early 1846, and the project was terminated after six fascicles.

WN: Twenty-four individual photographs were ultimately published. *The Pencil of Nature* is the very first instance where a printed text was illustrated with photographs. This is what Talbot said about the book in his introductory remarks: "The little work now presented to the Public is the first attempt to publish a series of plates or pictures wholly executed by the new art of Photogenic Drawing, without any aid whatever from the artist's pencil." He gave a brief history of his discovery of the process, and then, facing each of the plates, which had been fixed by hand to the pages with wet adhesives, he provided interpretive texts.

You might describe *The Pencil of Nature* as the first history of photography by one of its inventors; it's all retrospective. Talbot tries to put the images into a broad historical and cultural context. This is one reason the book is of more than mere academic interest; it's an important benchmark in Western intellectual history.

DF: The first print we will look at today is an image of a botanical specimen, a pea bean (pl. 1). It has been given a probable date of February 6, 1836. This is a photogram—the image was made by laying the plant directly on sensitized paper.

Geoffrey Batchen: We could talk about this single print all day because it sums up the fundamental nature of the pictures that Talbot was able to come up with in 1834, 1835, and 1836. This image is actually produced by the thing that is depicted. It's that kind of direct, physical, causal relationship that makes photography such a distinctive medium. When we look at this, it recalls the fact that at one point the specimen and the image were in fact touching each other. Even though the real thing is now removed, the picture still has the linear perspective of that presence. Given the idea, in the biography that Larry just outlined, that Talbot was an incredibly well-educated man and an omnivorous thinker, I can't help but imagine that he must have pondered at length the very nature of the process.

Often this kind of image is referred to as a negative, but even though Talbot himself considered the possibility of negative to positive quite early, in 1835 and 1836 he never made positive prints from this kind of negative. I think we have to treat it as an image, as he treated it at that time.

WN: What we are looking at here—the outline of a plant against a grayish purple background—is one of the earliest surviving examples where nature has created its own image photographically. Imagine the excitement that must have occurred in Talbot's mind when he achieved this! This shred of paper is the manifestation of at least two hundred years of wishful thinking that nature could make its own pictures. What an exciting, epochal moment!

Michael Ware: When Talbot made this, I am pretty confident that the areas that are now pale gray would have been a dead white, and it would have looked much more dramatic to him than it does to us now. Today this image is almost on the margins of existence; for me, it's very eloquent testimony to the difficulty of making those very first photographs.

LS: This picture is heartbreakingly beautiful. We're not only seeing Talbot's thoughts here, we're seeing him preserving, as one contemporary critic said about *The Pencil of Nature,* "the sunshine of yesterday." This plant would have withered very shortly after this photograph was made, yet its image has lasted now for almost two centuries in quite an extraordinary way.

GB: I disagree with your point, Weston, that this is the culmination of two hundred

years of wishful thinking. To me, this is an extraordinarily modern conception. In my own work, I've tried to argue that the very conception of photography is peculiar to the modern period, by which I mean from around 1800 on.

WN: In the popular photographic press from 1889—the year that was considered the fiftieth anniversary of the invention of the medium—people remembering back to the days of the first announcement of photography spoke of it as the fulfillment of a dream. I've always accepted this as a bona fide interpretation of history—that Talbot succeeded in realizing a dream that had been expressed by many people for a long time, and that he was accorded a significant amount of credit by his contemporaries long after the controversy of who invented what in 1839.

GB: I think the most important word to use in relation to this picture is *surviving*. This wasn't the first time such an image had been made, because Thomas Wedgwood and Humphry Davy had experimented with producing such impressions around 1800, and many other people were familiar with the chemistry that was necessary and could also make such pictures. Even Talbot himself said that he had friends, whom he doesn't name, who had tried but had never been able to fix an image. So the question of this print's survival is the real breakthrough.

LS: Talbot claimed—and we'll have to take him at his word since there's no contrary evidence—that he had no knowledge of these earlier efforts, that the idea was fresh to him at Lake Como. But it developed in an environment of that long period of different people experimenting.

MW: I accept Geoff's point, but at the same time, Weston probably has in mind experiments such as that of Johann Heinrich Schulze, published in 1727; he did something very similar by using paper stencils to throw the shadows of letters onto a sensitized silver surface. It wasn't laid down on paper like a conventional photographic image but was in suspension in solution. But the process was certainly known in 1725 and probably could have been accomplished in 1625, since silver chloride was known then.

DF: What term did Talbot use to describe what he was doing? What would he have called this?

LS: Remember that this was done in a private period, when Talbot was neither publishing nor showing his experiments to other people. The most direct answer is that he called it sciagraphy, which is a term borrowed from a form of puppet theater, where objects are depicted through their shadows. By using that term, he was seeing this as the shadow of a thing. He wasn't seeing it as the thing but as this rather mystical object called a shadow that follows everything around and that has always been an intriguing concept.

DF: But in seeing it as a shadow, he is still making a mental jump, because the shadow in the image is light and not dark.

LS: Yes, he was acknowledging the negative-positive concept, even though he was not using those terms.

MW: I would take issue with Geoff's earlier discussion of whether or not this is a negative. Instead of defining a negative in terms of its functionality, as an object from which you make a print, I would simply define the term by the tonal quality. A negative reverses light and dark. It's a negative whether you make a print from it or not.

GB: The only reason I am quibbling over the word is that—the way we use negative and positive today—there's a derogatory connotation attached to the negative. The positive is the ultimate result. You can really get distracted from what this print is by imagining that it's only halfway there. I don't think that Talbot had making a positive in mind; at this stage, this was enough.

MW: But the negative is as important as the positive, if not more so, as the primary photochemical event.

GB: The prime issue here is the ability for the image to survive. The desire to use this kind of chemistry and make pictures from nature was, in fact, one that had been around for thirty years before Talbot managed to solve the problem of fixing an image. In that sense, photography is a product of a variety of cultural changes that occurred in the decades around 1800, and Talbot certainly should be celebrated as the man who resolved the various technical and conceptual problems that arose from those consistent changes that were occurring.

Nancy Keeler: I agree with that. The excitement here is that it's been done—the image is fixed. The other aspect of this picture that strikes me is something Larry has mentioned elsewhere—the philosophical purity of the moment. This was in Talbot's mind as he was working in his lab to solve a problem, and he finally came up with the solution. It becomes iconic in the sense that it was untainted by commercial thoughts. It's a pure idea.

LS: It's a pure physical manifestation of the imagination.

NK: Yes.

LS: Talbot came to this—I would have to accept his own word on it—as a virgin. He didn't say, "Wedgwood couldn't solve this, and Davy couldn't solve this; I'm trying to solve this." He approached it saying, "I have an idea." Later, of course, he would have drawn from the general application of that collective knowledge Weston was referring to. He would have put this into the context of human history, of the several hundred years, if not more, of the kind of thought that led to this image.

GB: The process Talbot used was extraordinary, but I'm sure that, for him, part of the jubilation was that the image he made out of the process was actually quite familiar. If you look at the formal conventions of this picture, it fits within a tradition of scientific illustration with which he was, of course, familiar and in which he was an expert. The formal values actually fit within a familiar set of conventions—isolation, the symmetry on the page, the exposition of each of the parts of the plant.

MW: He was a significant botanist, wasn't he?

LS: Yes, he was.

WN: It's interesting that of all the objects he could have placed on the sensitized paper, he chose plants.

GB: He chose plants in this instance, but he was also recording samples of his own handwriting. In 1834 his sister-in-law Laura Mundy wrote to him saying, "Thank you very much for sending me such beautiful shadows," and she mentioned images of both drawing and writing. What's interesting to me is that he used examples of nature and culture as the subjects for his early pictures.

LS: But the preponderance of the surviving items is botanical. Talbot had an intense interest in botanical illustrations and in making them available. In fact, in 1839 he wrote to the botanist William Jackson Hooker and said, "Let's do a botanical book, a book with photographic illustrations." It didn't happen, but that thought was there.

NK: He and John Herschel sent samples of photograms back and forth, didn't they?

LS: Talbot sent plant photograms and also plants. When Herschel went to South Africa, Talbot wrote and asked him to bring plants back for him.

DF: Let me introduce a second picture into our discussion by posing a question. The print, dated April 1839, is titled *Asplenium Halleri, Grande Chartreuse 1821 —Cardamine Pratensis* (pl. 4). What did Talbot do differently from Wedgwood and the others that allows us to be looking at this photograph today?

MW: It's a question of fixation that is beautifully illustrated by viewing our first two images side by side. At the time of the 1836 picture, Talbot knew nothing of the ability of hypo—sodium thiosulfate—to fix images. He did know about it when he made the 1839 picture, but he chose not to use it.

So leave modern fixation to one side for the moment. Talbot's first success with fixing an image was an accidental observation. He coated the paper in two stages. He first soaked it in common table salt, sodium chloride. This was abundant, so he probably put the paper in a trough of it. When the paper dried, he coated it with silver nitrate. Being much more expensive, this would have been swabbed or brushed on in smaller amounts. What he observed was counterintuitive. Any chemist would probably expect that to make silver chloride from sodium chloride and silver nitrate, an exact proportion of the two according to chemical theory would be best. This was not so. Where there was a deficiency of salt, the coating was more sensitive.

That was an important discovery, because it enabled him to shorten his exposures and get more robust images more rapidly. But he also reasoned the converse, and this is an elegant and vital step. If a deficiency of salt enhances the sensitivity, then an excess of salt will diminish it. That led him directly to salt fixation, which he probably would have applied to the 1836 image, but not very effectively. There are many prints like it, broadly of the same color.

The salt, in fact, does not remove the excess unexposed silver chloride; it merely renders it less sensitive to light. That's why these images still fog, ultimately. I said that where the plant had been originally, it must have been white, but over the years, possibly very quickly, maybe within a few weeks, those areas fogged up and acquired density.

Salt is sodium chloride, but there are other halides, notably bromide and iodide. Talbot experimented with these and found that iodides were particularly effective in fixation. That is probably what we're looking at in the 1839 print, because it has a primrose yellow background, the characteristic color of silver iodide. After making this image, he treated it with a strong solution of potassium iodide, which had the effect of converting the excess unexposed sodium chloride into silver iodide and producing a yellow image that is very stable to light. This particular example has persisted pretty well, although the ground has probably faded.

WN: The title suggests that this plant was collected in Grande Chartreuse in 1821. Is that possible?

LS: Yes, because he was probably in France then.

WN: So for this image he's taken a sample from a plant that he collected in 1821 and nurtured for eighteen years. It doesn't look very spectacular in this image, but it was considered a valuable specimen.

GB: It had value as a rare specimen, but it also had sentimental value due to the personal attachment.

LS: He sent this image to his aunt, Lady Lansdowne, who quite possibly was there when he collected the original plant.

WN: When this picture was sent to her, it was folded up and put into an envelope. When the Getty Museum acquired it, it was still in the envelope.

LS: In April 1839 Talbot was under great pressure to produce things.

WN: Yes. What we've not talked about directly is that between February 1836, when the first image was made, and April 1839, the date of the second picture, everything changed. In January 1839 Talbot learned about Daguerre.

LS: We don't know exactly when Talbot learned about Daguerre's announcement, which was made in Paris on January 7, but it was probably the second or third week of January. The Royal Institution very quickly put together an exhibition in its library, which Michael Faraday introduced in an evening lecture on Friday, January 25. That was probably the first public opportunity Talbot had to present his images, and he showed things that he already had in stock. Then on January 31 he gave his first paper to the Royal Society, *Some Account of the Art of Photogenic Drawing*, at which time he described the concept of photography. He didn't discuss the mechanics then, but a couple of weeks later he disclosed how to do it. I don't think he held back; that was just the way it played out.

This image was made three months later, but the rush to get new photographs out to the public happened during a winter that was one of the worst on record. He had a hard time producing anything by April 1839 because there just wasn't any sunlight.

WN: Perhaps we can look at the obvious visual differences between the two pictures. The later one is larger, with a harder-edged, crisper feeling; it is less subtle, more finished. But it is only by comparison that you can say it appears less experimental. It seems to me that between 1836 and 1839 there had been a vast change in the way Talbot saw and felt about his new process. At some point we might also want to address how these pictures stopped being called sciagraphs and became photogenic drawings, then finally photographs.

GB: What strikes me in the comparison is that, from the 1836 to the 1839 image, Talbot adopted a consolidation of the pictorial. The later work is incredibly symmetrical; the two plant fronds are clearly separated, carefully flattened out. This is about science and the accurate rendering of scientific samples. It's as if, even as early as 1839, through the pictorial conventions that he adopted, Talbot was making a case for photography that was different from the one that, say, Hippolyte Bayard was trying to make in Paris. Bayard used the edge of the paper as a cropping device, with forms coming in and out of the picture frame. His images are about pictures and pictorial surfaces; this one by Talbot is about illustration and scientific accuracy.

LS: The term *sciagraphy* never made it to the public. I see that word as Talbot's way of conceiving of what he had come up with. In his private notebooks he also used *photogenic drawing* early on. When Faraday introduced Talbot's work on January 25, there wasn't a term; by January 31 the process was called photogenic drawing. Herschel and many others immediately objected to the inflexibility of that term. He didn't want people labeling themselves as "photogenisizers." Herschel is also one of the people who said very early that, with terms like *lithography* and *telegraphy* and a number of others in use, *photography* was a more flexible root word. And by April, Talbot had obviously accepted that, by the way he inscribed this negative "H. F. Talbot Photogr."

WN: But didn't Sir Charles Wheatstone use the term first?

LS: Wheatstone's use was in a private letter on February 2, 1839, and as far as we know, it received no public circulation. On February 10 Herschel also used it in a private letter. The first publication of the word *photography*, which I doubt had much circulation, was in a small provincial paper in Germany on February 25. I would consider Herschel's publication of the term in his "Note on the Art of Photography," delivered to the Royal Society on March 14, to be the official introduction.

GB: One thing the adoption of the word shows is the acceptance that both daguerreotyping and photogenic drawing are of the same family and that you have to make up a word that can somehow incorporate both branches.

LS: I don't think that's the case. Most people kept a very careful distinction through the 1840s between photography and daguerreotyping. The daguerreotype was identified with Daguerre. But in the parallel situation, Talbot, quite modestly and in keeping with how he had been brought up, didn't name his invention after himself, he named it after the process. When he came out with his second process, the calotype, there was quite a bit of pressure to call it the Talbotype (see p. 144), but he didn't want that.

DF: Let's move to a much different kind of image. *Wall in Melon Ground, Lacock Abbey,* is dated May 2, 1840. We have two examples of this. One is the original photogenic drawing negative (pl. 11); the other is a salt print from the negative (pl. 12).

MW: The first two images we looked at were contact prints; this negative was made in a camera. I want to stress the fact that, roughly speaking, it is about a thousand times more difficult to make a negative in a camera than to make a contact print. The sun is blazing down on the piece of paper when you make a contact print, but in the camera you are allowing a very small amount of light to pass through the aperture of a lens.

I think Talbot was yearning for more detail in his botanical images. In his *Notebook M,* dated February 28, 1835, in the passage that follows Talbot's use of the word *sciagraphic* that Larry mentioned, Talbot writes, "If an object, as a flower, be strongly illuminated & its image formed by a camera obscura, perhaps a drawing might be effected of it, in which case not its outline merely would be obtained, but other details of it." He was looking for more than just the outline, and that leads in a natural way to the camera image. At that time he had not succeeded in making a camera image of a plant, because it wasn't illuminated strongly enough.

WN: I'd like to give a little perspective of time to this picture. We know that Herschel recorded something about Daguerre's process on January 22, 1839, which we assume is approximately the same time that Talbot learned about it.

LS: That January, they didn't really know what the daguerreotype was. They had no description of it; they didn't even know it was on a metal plate. All Herschel knew was that Daguerre had succeeded in securing images in the camera obscura, but he was fascinated. Immediately all of his previous experiments and education fell into place. Herschel was a good sketcher himself, so Talbot's motivation to invent photography never occurred to him. But as soon as Herschel heard about Daguerre's process, he immediately understood how to do something like it.

WN: On May 9, after Herschel had seen his first daguerreotype, he wrote: "It's hardly saying too much to call them miraculous. Certainly they surpass anything I could have conceived as within the bounds of reasonable expectation. The most elaborate engraving falls short." He went on to say, "They make Talbot's work look like misty images."

I want to consider this study of a garden, which was created in 1840, in the context of Herschel's unfavorable response the year before to what Talbot had invented. Is it possible that this burst of activity outdoors—drawing from Mike's

statement about Talbot moving away from the contact prints into something that resembles a picture made from a scene from nature itself—was Talbot trying to make images more pictorial and less experimental?

NK: First of all, the winter and spring of 1840 was a time of extraordinarily good weather in England. That prompted intense photographic activity and perhaps even contributed to the success of the camera images. I don't think Talbot was discouraged by anything that Herschel said; every day he made more and more encouraging experiments. It was in this period that he submitted a large group of photographs to various groups of artists—to the Académie des Beaux Arts in Paris and the Graphic Society in England. He was branching out from thinking of this as a scientific experiment into thinking of these as pictorial creations. Talbot found out that Bayard had received a very favorable report on his direct-positive process from the Académie des Beaux Arts, and that's what prompted him to submit his portfolio of thirty images.

DF: Was he submitting what we would call positive prints made from a camera negative at that point?

NK: Yes.

LS: And often sending the same images to different recipients.

NK: So he was conscious of soliciting higher artistic opinion. You might even say that the nucleus of *The Pencil of Nature* was born in this time period of the winter and spring of 1840. The Graphic Society commented on this very image, or others that are similar to it. The *Literary Gazette* wrote: "We have been gratified by an examination of a series of photogenic drawings, which Mr. Fox Talbot has produced during his spring residence in the country. . . . Various views of Lacock Abbey, . . . of trees, of old walls and buildings with implements of husbandry; of carriages; of tables covered with breakfast things; of busts and statues; and in short, of every matter from a botanical specimen to a fine landscape, from an ancient record to an ancient abbey are given with a fidelity that is altogether wonderful." I think this list of intensive photography of every corner of his country estate is very moving. The images became a collective portrait of Lacock Abbey and of the life Talbot lived there as a country gentleman.

LS: We need to bear in mind the technological triumph here—this is still a photogenic drawing negative done only with light; there's no development. It is strictly solar energy depositing the silver. Talbot had refined his processes enormously within the past year to the point where he could take a full-plate negative in a camera with a decent exposure. He couldn't have made a sketch in ten minutes, but he could make this camera negative in ten minutes.

Remember, we started with a man who said he couldn't draw, and certainly his surviving drawings would bolster that opinion. When he pulled this image out of the camera, he could see immediately what nature had put on that piece of paper. There is such tremendous personal aesthetic growth from his earlier depictions of an object to this point, where he is actually structuring an image, recording a scene. He is finally able to be an artist in a way that he couldn't have dreamed of even ten years before.

MW: I agree entirely with what Larry has said, but I think the exposure may have been a good deal longer than ten minutes. This is clearly a brightly sunlit subject. We can see specular reflections from the metal of the shovel, but we are not seeing hard shadows. There is a very diffuse shadow, particularly of the broom handle.

To me, the implication of this is that the negative may well have been given an hour or two of exposure. One can assess that very roughly from the relative motion of the shadows. The sun is moving at an angular speed of fifteen degrees of arc per hour, and that is moving the shadow of the broom handle from left to right at a certain rate, but it is smearing it out. If the exposure is on the order of a half hour, you're not going to get a full shadow of the broom handle, just the ghost of a shadow. The relative movement of the sun is shifting the direction of the illumination and therefore blurring out and to some extent eliminating the shadows of the objects. What this does is give the image a wonderful, almost unnatural, luminosity. I think that residual blot next to the watering can is the final umbra, the little bit of shadow that the sun never peeped into.

LS: What Mike is saying aesthetically is very important. There is a generalizing roundness that comes about from the exposure length. Herschel, in fact, reacted to this particular picture in a very positive way. Talbot sent him a copy, and he wrote back immediately: "I am very much obliged indeed by your <u>very</u> <u>very</u> beautiful pho-

tographs. It is quite delightful to see the art grow under your hands in this way. Had you suddenly a twelvemonth ago been shown them, how you <u>would</u> have jumped & clapped hands (i.e. if you ever do such a thing)." Then he commented on "the corner of a sunny wall with garden tools" and was very enthusiastic about "how admirably the broom shows—and the shine of the spade."

GB: There are two things we haven't dwelt on yet. One is that we are looking at two images, a negative and a positive. That means, among other things, that Talbot could send a copy to Herschel and a copy to Paris, that we have the beginnings of the possibility of multiple reproductions from a single matrix. That's a really important development. Talbot made a statement here by showing something that his process could do in relation to the daguerreotype. And by sending an image off to different countries in the same week, he demonstrated that the same image could be in different places at the same time.

The second thing is the subject matter itself. It's interesting that the *Literary Gazette* described this as an old wall. The editors already have an interpretive frame for this—this is a picture about age, about history. And, of course, it's a self-portrait of Lacock Abbey, a set of buildings that Talbot was inordinately proud of and whose history he constantly referred to. Here he's making a picture of an old wall at a time, in 1840, when history was an intensely important subject. In a sense, our modern notion of history comes into being in the late eighteenth century, perhaps marked by the beginnings of the French Revolution. There was an acute interest in the traces of history, the old ways of doing things.

The symmetry of this is striking: the broom and shovel on one side, the watering can and pitchfork on the other. It's almost too symmetrically organized. It suggests again that he's an artist who is not sufficiently familiar with pictorial conventions to be able to play with them much at this point. He organizes carefully, and everything fits in the right place.

James Fee: I don't agree; I think this is very sophisticated. It's very symmetrical, but the wall completely eradicates that. For me, this is a very powerful composition.

LS: I don't think anyone even thought about trying to structure an image like this five years earlier.

JF: That's true. Talbot was the first artist to be trained by photography; this is where he learned how to see.

LS: If I had a student who started where Talbot did with his drawing, and got to this point, I'd say this was tremendous. But I don't see this as being about history so much as being about everyday life. I think he saw this as part of his ordinary existence, but of course we have no way of knowing.

WN: I agree with Geoff that it's about history. And the reason why is that, first, it's the element of time represented by the stone wall. Just the very fabrication of the wall represents a layering of time, of time past. Secondly, the tools are highly traditional implements that had been used for decades, if not centuries, on farms.

DF: The images we've looked at so far were done at Lacock Abbey, so on a very basic level *Nelson's Column under Construction in Trafalgar Square, London* (pl. 39), from April 1844, is different because Talbot has taken his camera someplace else. Since part of what Talbot was doing early on was trying to understand his process— experimenting—I suppose there was really no reason to go elsewhere just to see if his theories worked.

LS: That's right, but in fact he did venture out soon after he began photographing. He actually said that he didn't find Lacock Abbey very promising for pictures; he didn't find it very picturesque.

WN: This is the first image we've looked at that has historical as well as scientific or aesthetic importance. The historical event being commemorated here is the erection of a monument to Lord Nelson in Trafalgar Square. It was highly controversial at the time because of the design of the column and its prominent position opposite the National Gallery. Some people considered it grotesque. So it seems to me that this is one of Talbot's first attempts at practicing what we would think of today as a kind of journalism, of telling a story through a picture about something that was being talked about generally, and perhaps, through the picture, even to express an opinion.

 If you think about the opinion being expressed here, I don't believe that he was trying to flatter the design. He chose a viewpoint with a foreground that I find absolutely charming, with the billboards and the "no bills" sign and the framework

of the construction timbers still on the base. He shows how large and dominating the monument was by using the optical aspects of the camera in this particular place. It seems that Talbot is actually editorializing here; he's creating a picture to support an opinion about the column's design.

LS: May I offer a different interpretation? The monument was a colossal public-financing failure, and construction had stopped because the money had run out. Most of the controversy was about the failure of the project, not about the design of the column itself.

This was the first public space ever set up in London, and a lot of the controversy about it was the fact that it might encourage riotous behavior. In this picture, which I think is wonderfully composed, Talbot is really looking at that open area to the left. Those who have been to the site know that there are two giant fountains there. Those were not put in for aesthetic purposes, but to break up crowds. And the base of the monument was raised in order to make it more difficult for it to be used as a speakers' platform.

You have to remember that Talbot was involved quite intimately with running an estate at a time of tremendous social upheaval. To me, this picture is about his awareness of the concerns about the Chartist uprisings. In fact, this was the scene of one of the first Chartist riots just three years later. To this day, Trafalgar Square remains the favored site in London for political demonstrations.

GB: Are you arguing that he took the picture in order to induce people to put money into the project?

LS: No, I think he took the picture because he was interested in the concept of this open space. It's one of two photographs he took there about six months apart, and they are both framed rather similarly. They both emphasize the open space, not the monument.

JF: What I find interesting about this picture is the perspective. He's chosen a higher angle of view, and I think that's a tremendous step forward photographically from *Wall in Melon Ground.*

GB: Given how often Talbot concentrated on symmetry, here he allows the column to go off into infinite space on top of the picture plane. It's an extraordinary thing. I

don't know how he could have prevented it, but he chose not to take this vertically. He composed it horizontally, which forces the column to be truncated and to shoot up into space.

MW: The contrast with the church spire of St. Martin-in-the-Fields makes a poignant statement.

LS: A number of people, including Herschel, had given Talbot advice about converging lines. Part of the reason why I think he started adopting the higher point of view was so he wouldn't have to tilt the camera up.

JF: Does that mean his camera didn't have perspective controls?

LS: It did have them, but they weren't used commonly. This elevation also allowed him to look over the board fence to see that space. If he were at street level, he couldn't have seen it.

MW: The light area on the facade of Morley's Hotel, just to the right of the column base, is where the sun was reflecting most strongly, I think.

GB: That's the hot spot. It seems to me that he composed the picture—and placed the top edge of the picture plane where it is—because he organized the image around a desire to contain that bright area. If he really wanted to tell us about public space and the relationship of the column to it, as Larry suggests, he could have shifted away from the hot spot, placed the column on the right side of the picture, and shown us a lot more of that space. But in fact, he put the column and its base at the very center of the picture, so that's what he wants us to look at.

NK: How would you situate this in his overall reportage, if you want to call it that, of the city of London? I don't know how many pictures of London he took, but I've only seen about ten of them published.

LS: There are quite a lot of them. Nicolaas Henneman moved to London not long after this picture was taken, and I can't reliably separate what he did from what Talbot did. But Talbot took this particular picture. I happen to know that he was in London to see the daguerreotypist Antoine Claudet within a day of when this image was made.

DF: What was Henneman's relationship to Talbot?

NK: Henneman was initially Talbot's servant but quickly became his foremost assistant in the earliest photographic experiments. He is one of the figures in early British photography of whom we know quite a lot. People have written about him, but I think that we haven't really separated his work from Talbot's. He's always seen in Talbot's shadow, yet some of the pictures in *The Pencil of Nature* are, in fact, by Henneman. Talbot eventually set him up in business in a printing establishment in Reading, and that's where prints like this of Trafalgar Square entered into mass production. It was a whole new phase for Talbot.

DF: What year did the business start?

LS: In 1843, Talbot financed it, but it was very much Henneman's business; he established the first calotype works and made his way with that. He was the person who worked most closely with Talbot at Lacock Abbey. As Talbot was discovering things, both in visual and physical terms, Henneman was right there. From the beginning he was making a lot of prints; he was certainly making a lot of negatives. Except in a few cases of definite record, it's impossible to say whether something can be credited to Henneman or Talbot. If the two of them were here today, they would probably find that a puzzling speculation, because they worked together to produce these images.

MW: The exposure here wouldn't have been much, a matter of two to five minutes at most. The print has good depth of field, and I think they stopped the lens down.

 If I may, I'll use this as a footnote to my exegesis on fixation. This is the first example we've seen of a clear case of thiosulfate fixation. This is a hypo-fixed image; that is, fixed in the modern way. The highlights are absolutely clear, there's no chemical left in the white paper, and the color is fairly typical. Those beautiful colors that we saw in the botanical specimen are no longer present.

 This was standard practice at Henneman's studio in Reading. He is not just halide-stabilizing here; he is thiosulfate-fixing to achieve what he hoped would be a permanent image. In many cases, though, he was destined to be disappointed.

LS: Talbot had come to accept that washing out the hypo was an important factor. The price of hypo had come down a lot, but there was no quality control, and they

constantly had trouble getting good batches from the chemist. There was also a chronic water shortage at the time in Reading. And then they couldn't afford the fuel to heat the water and, of course, when the water is cold it isn't as efficient at washing out prints. Thanks to Thomas Malone, they discovered that if they left a little hypo in the prints and ironed them, they turned a very pretty brown.

MW: So it was possible to tweak the color at the fixing stage with a range of browns and purplish browns.

LS: Yes. The speed with which you print also affects the color. It affects the particle size, and that affects not only the contrast but also the color. When Talbot was printing at Lacock Abbey, he could pick and choose when to work, because there was no pressure to turn out a print at any given time. When Henneman was working at Reading, as long as it wasn't raining, he was forced to try to make prints. If he had an overcast day and had to make the prints very slowly, he'd wind up with a lower contrast print that was much warmer in tone and also less permanent. So not all of these were conscious aesthetic decisions; it was also practicality.

GB: One thing this tells us is that photography was now an industrial process. Talbot doesn't do it; Henneman does. The aim is to get the prints as similar to each other as possible in a fast and cost-efficient way. There is a sense of mechanical mass production at work. Do we know if Talbot made a master print and then asked Henneman to replicate it?

LS: No, I don't think he ever did that. I think Henneman made some of the first prints and then Talbot commented on them—"too dark," etc. There are just a few instances where we can track particular prints.

DF: The pair of pictures we're going to look at next take Talbot to two other locations. *High Street, Oxford* (pl. 28) is most likely from July 1842; *The Boulevards of Paris* (pl. 33) was made in May 1843.

GB: They make a nice contrast. The Oxford picture is very appealing to a twentieth-century sensibility, with that chain going out of the frame at the corner the way it does. It's a really amazing shot.

WN: What we're talking about here is how a composition is built by either deliberately harnessing elements of a subject or accidentally having the resolving power of the lens and the perspective become the organizing features of the picture.

GB: That's right, although by 1842 I think Talbot was very deliberate.

WN. Did he have a viewfinder at this point? Was he completely visualizing the picture, seeing it through a viewing screen?

LS: I would assume that by this point he used a ground glass in the same way that we would today, but we don't really know anything with any certainty about Talbot's cameras.

GB: The question is whether Talbot preconceived the line formed by the chain or not. In a way it doesn't matter; he obviously welcomed it from the fact that he printed the image afterwards.

LS: A lot of prints were made of this, so he liked it.

GB: It may have been a very happy accident, but I tend to think it was deliberate since the height of the camera is also designed to give us a sense of intimacy with this space. It's almost as if you could step into the picture.

LS: This was the grand entry to Oxford at the time, crossing the Magdalen Bridge. The coach would come up from London, and this is the magical first view of Oxford that travelers would see.

GB: The way the trees frame the buildings and mirror the curve of the streetscape is an extraordinary kind of perfection.

MW: And there is that little stroke of serendipity where those upper windows on the left reflect a white cloud; that light really lifts the massive facade, because the sun is coming from behind that building.

LS: Going back to Weston's earlier question, almost all of Talbot's cameras had a rectangular proportion, so this negative was probably cut down to more of a square. I assume that the foreground became unacceptably blurry to him, so he cut the bottom portion off.

WN: Right, that's what I was wondering. But it is a spectacular composition. The light coming through the trees on the right is quite lovely. That combination of transparency and density is something an artist could easily have drawn if he were using pencil or graphite. Unlike the Trafalgar Square picture, which somehow seems a complete composition with all the elements working toward each other, in this one my eyes always want to go to the fragments. And that is a curious phenomenon.

NK: In what way?

WN: I go to the foreground, I go to the reflection, and I can't stay out of the background.

LS: If you were standing there, your eye would look past the fence and concentrate your attention where the picture does, so the out-of-focus area coaxes you into the image.

WN: The difference in tonalities between this and the Paris picture is interesting. In order to get the depth of tone in the Paris picture, it appears as though Talbot had to print the negative so that the sky had a mottled effect. In the Oxford picture, he may have wanted the sky to be totally unmarked by traces of silver and would have had to underprint it, sacrificing the background.

MW: If we could compare the original negatives of these two, we would find the one of the Paris picture to be full of contrast, simply because the sun is shining straight down the boulevard and reflecting off the faces of the buildings. To print that down, he would have had to print the negative using a long exposure. In the Oxford picture, however, the shadows of the posts show that the sun is cutting straight across the picture. It isn't causing the same reflective problems, so the print could be made with a shorter exposure, leaving the sky clear.

LS: Although he didn't phrase it this way, Talbot basically exposed for shadows and developed for highlights. We don't want to make him too much of a hero, but he understood that general procedure.

In the Paris picture Talbot very cleverly made use of the fact that they had just brought in the watering trucks to hold down the dust. He had the advantage of

shooting from his hotel room, so he could work at leisure. There are a number of negatives from that room in that hotel. This is probably the picture in *The Pencil of Nature* that he writes about most extensively and most intelligently.

WN: I have always been struck by what is represented in the roadway here. Since the unpaved street has just been dampened, what we're seeing is a phenomenon that was going to vanish shortly; it was going to dry and the lines would not be evident very much longer.

In the discussion in *The Pencil of Nature* of this image, he pointed out the shutter that's open in the building on the left and how the light catches that opening in a very special way. The fact that Talbot himself saw elements in his pictures that would soon vanish has always impressed me. He really looked at these scenes, and he knew what he was doing.

GB: Is it possible he had seen Daguerre's similar streetscapes?

LS: I don't know if he had seen those specifically, but he certainly had seen plenty of daguerreotypes by 1843. In *The Pencil of Nature* he referred to the detail that is possible in the calotype, obviously making a reference to what had been seen as the strength of the daguerreotype. He talked about the calotype's fantastic ability to render all these details in a reproducible form.

DF: Do we know where in Paris this is?

NK: It's the Boulevard des Capucines, at the corner of Rue de la Paix. If you were standing there now, you would be looking at the Place de l'Opéra. The building on the left was destroyed around 1858 to make way for the new opera. It's easy to find lithographic views of every building on the Boulevard des Capucines. You can locate the hotel that we're looking at and then find Talbot's hotel, the Hotel de Douvres. Both were places where a lot of English visitors stayed.

DF: Was this the first time he had taken his camera to Paris?

NK: I think so. I don't think he had been to Paris since before the invention of photography.

LS: No, although he had been traveling a bit. On this trip he was trying to patent the calotype in France, but more importantly, he was trying to market the calotype there. He was attempting to get people to use it.

NK: As far as I'm concerned, one of the big holes in Talbot scholarship today regards his trip to France. He was very anxious about the direct-positive process on paper that Bayard had invented. Even though today we consider that a little cul-de-sac in the history of photography, in its time it was quite well received. Talbot did not want to be outpaced by another French inventor using a paper process, and this led him to want to go to France and begin to make his invention well known. He established a business relationship with a French aristocrat, the Marquis de Bassano.

In the vision that emerged out of their relationship, calotypists would be trained in Paris and then sent out all over France. Individual photographers would send their pictures back to the central company, which would concern itself with printing. This was a huge conceptual leap toward competition with other print media. The reproducibility of the calotype was its principal strength over the daguerreotype and Bayard's direct-positive process, both of which created a single, unique image.

We only know a fraction of the pictures that Talbot took on this trip, but at least two of them appear in *The Pencil of Nature*. The relationship with the Marquis de Bassano ultimately never came to anything, but through it Talbot firmed up the ideas that he would realize in the Reading establishment just a few months later. He was in Paris in May and June of 1843; by early 1844 the Reading establishment was up and running along the same lines he had envisioned in France.

LS: Talbot went to Paris in a position of confidence and strength, as well he should have. He had mastered the process and learned to be an artist of whatever degree. He was producing plates consistently. He had both *The Pencil of Nature* and the Reading establishment in mind at this point. He went into Daguerre's territory saying, "I can do what he can, plus publish editions of prints." His process was about detail and reproducibility, and he had every reason to be very confident.

WN: To put this in context within photographic history, Hill and Adamson, Talbot's Scottish disciples, had begun to explore the architecture of the city of St. Andrews by this time. Is that correct?

GB: That's right.

WN: So by 1843 the various practitioners of Talbot's process had begun to address their subjects in specific ways, and Talbot, at this point, was walking in step. This presents us with an opportunity to talk about Bayard, who was working in Paris at the very same moment. Is it fair to describe him as using Talbot's process?

NK: While Talbot's method, as we know, started from the negative and required a second step to arrive at a positive image, Bayard's direct-positive method produced a positive in one step. Being on paper, his prints lacked the crisp definition of a daguerreotype, but since there was no paper negative, Bayard's direct prints were sharper than Talbot's photogenic drawings. They were much appreciated by the artists in Paris, and the initial success of this French paper process was responsible for Talbot's efforts to bring negative-positive photography to France. Talbot had a shaky start there, but his negative-positive process eventually won converts, including Bayard, who produced most of his brilliant work of the 1840s using Talbot's process.

WN: Did Bayard and Talbot meet when Talbot was there in 1843?

NK: I would love to be able to say so, but so far there is no proof. We haven't found any evidence yet, but there is still a lot of material to go through.

WN: Then if Bayard didn't learn the process from Talbot, from whom would he have learned it?

NK: From the workshop set up in the Place du Carrousel. Part of the exploitation agreement with the Marquis de Bassano established a teaching workshop.

LS: Talbot's brilliance, and also his downfall, was that he was always a little bit ahead of the curve. He had the idea of this establishment in Paris a little before it could be accomplished, and he had the idea for *The Pencil of Nature* a little too early. I have to go back to what his son said, that Talbot had an original mind and disliked laborious application on beaten paths. I think that by about 1845 he was ready for photography to be involved in the outside world; he wanted to go on to something else.

DF: *The Open Door* (pl. 40), which Talbot made at about this time, in April 1844, is certainly the image that is most identified with him.

GB: This is easily the most discussed picture that Talbot ever made, partly because he provided an artistic reading of it in *The Pencil of Nature.* Larry's research has given us a fantastic history of the making of this photograph, so that we understand now that it was hatched over a three-year period with different permutations.

LS: This is the entrance to the stables in the north courtyard of Lacock Abbey. It's a relatively shallow building, basically one room deep, right next to a brewery. If Talbot had looked out diagonally across the courtyard from where his laboratory was, which was right above the kitchen, this is the door he would have seen. So he would have viewed this daily, in all sorts of different light. The lantern ordinarily would have been there, as would the bridle.

Everything here is placed very naturally; nothing has been added to the scene. We know that this is a composition he worked on again and again, and it finally coalesced in this picture, which is one of two very close variants made the same day.

DF: How many times did he work with this scene?

LS: There are four major versions that we know of, spread over a three-year period. He had the idea for this image early on and made prints of it, but it really didn't pull together until this one.

DF: That seems relevant in terms of how Talbot's understanding of photography progressed and how one can conceptualize an image over time.

LS: It's really the best example where you can see the idea for an image grow as Talbot worked with it. With most of the pictures he discovers something and then he's on to something else. But for some reason, he came back to this one again and again. His mother named it *The Soliloquy of the Broom,* and she obviously liked it very early on.

GB: Talbot had another title for it: *The Stable Door.*

LS: *The Stable Door* was the title he gave it when he exhibited it in the 1850s.

WN: But it was published in *The Pencil of Nature* as *The Open Door.*

MW: Is there a literalness to the metaphors the elements in the picture might suggest?

GB: Larry's research reminds us that Talbot was a very deliberate image maker. Nothing was accidental. He was an omnivorous intellectual, and, according to the British photohistorian Mike Weaver, there is nothing that Talbot did as a picture maker that wasn't imbued with his knowledge of literary and mythological sources. From Weaver's point of view, it's logical to jump back and forth between Talbot's work on English etymology and the history of myths and legends and to read into each of the symbols in this photograph very specific meanings, such as the broom sweeping clean the threshold of the mind, the lamp representing enlightenment, and so on.

Talbot refers to Dutch genre scenes as a pictorial reference for this work. And this is the picture upon which he based an argument for the possible use of photography as an artistic image-making process. With that in mind, it's not unreasonable to assume that he was indeed thinking of these things as having some kind of collective symbolic value.

LS: He did receive artistic feedback on this. The way he expressed it in *The Pencil of Nature* was a little tentative, but he basically said that people had been telling him to create a picture, not just a photographic record.

NK: He sees the realism of photography as a pictorial device. Has anyone looked at Talbot's poetry to see if there are philosophical ideas in it that might continue on in the photographs?

GB: It's nice that Lady Elisabeth called this *The Soliloquy of the Broom*, because it suggests a poet's reading. Talbot was not a great poet, but he was interested in the field. He lived next door to Thomas Moore, the biographer and friend of Lord Byron. Talbot definitely had an interest in romantic poetry, both as a quasi practitioner and as a scholar.

WN: The connection between a poem and a photograph has been made frequently; that is, the idea that a photograph can be a visual poem. In this picture I think we see Talbot coming closest to creating a classic sonnet, as opposed to a rhyming verse. A sonnet has to do, I think, with the interlocking quality of all the elements that form such a completely visual whole. But more essentially, it seems to me that a poem

is frequently important for what the poet suggests but doesn't say directly. Poetry, of all the literary forms, allows the maker to be ambiguous intentionally and to challenge the reader, or the observer, to distill the meaning that is put into the poem.

DF: If the next images we want to look at are poetic, it's in a much different way. *The Milliner's Window* (pl. 36), *Articles of China* (pl. 37), and *Articles of Glass on Three Shelves* (pl. 38) are all from about the same period, early 1844. What was Talbot's intention in doing these?

GB: These are not his most arresting images pictorially, but they are interesting for a number of reasons. First, in order to do them, Talbot set up shelves in the courtyard at Lacock Abbey, so the pictures pose as if they're interiors when in fact they were made outside. He had already realized that photography could project a certain artifice, that it could pretend to be one thing while actually being another. So much for the idea of photography's accuracy and objectivity!

Secondly, in *The Pencil of Nature,* he ties the china image to the notion that photography might have some legal use. If a thief should purloin these objects, proof of ownership could be determined by producing the picture in court. It is an important moment when Talbot explicitly links photography to the legal system and to the idea of property; that's a discourse that has continued around the medium ever since.

Then there are the pictorial, formal qualities of these works. They are perhaps Talbot's most abstract images. He doesn't show the supports for the shelves, instead allowing them to float in the photograph. You get a sense of where the camera is located in relation to the objects, but it's a very shallow sense of space.

NK: Why do you think he's done that?

GB: *The Milliner's Window* is the best example of why. Lady Elisabeth named it, and her title explicitly equates the aesthetic order of these pictures with modern consumer capitalism. This is the aesthetic of the shop window; it's about envy and the acquisition of property. Talbot has created a photographic style that mimics the way in which shop windows were being laid out in this period, but he's turned it into pictorial form.

MW: I accept your reading of this as a display of collectible objets d'art, but I think there may be a scientific reading as well, particularly in the china and glass pictures. Talbot was concerned about the nature of substance, about the passage of light through the glass. Whether this has any historical resonance with his earlier interest in spectroscopy, in breaking up the spectrum to investigate colors, is a natural conjecture.

LS: He writes about the difficulty of photographing glass and china together, because they reflect the world around them differently.

JF: In the glassware print there is a reflection of white on the glass; it appears as though he is using a reflector. Hill and Adamson did that quite often, but did Talbot also use reflected light?

LS: Talbot became aware very early on of the value of reflectors and screens, certainly before Hill and Adamson did. If he made this picture where I think he did at Lacock, he was taking advantage of northern light. He had a large panel and was using it to further illuminate these.

MW: It could also have been a cloud.

JF: You can almost see a cloud in one piece, but the reflection in most of the glassware looks very much like a rectangular panel to me.

LS: He had some sheets that he used as backdrops for portraits, so he would have had something on hand he could have used for a reflector if the sky itself didn't produce enough light. But he was certainly very aware of the concept.

GB: *The Milliner's Window* is one of my favorite pictures. It repeats many of the motifs of the other two, but the sheer number of bonnets here suggests how important they must have been as an element of fashion at the time.

WN: This is not a brilliant print, but it still gives a sense of how different clothing was then. For me, this almost becomes a study of found objects.

MW: These three images are constructed in a very similar way, but I am struck by the increasing dissymmetry as you go from glass through porcelain to silk and lace.

The glass image has absolutely perfect bilateral symmetry, apart from the handle on the top row, and everything reflects about the vertical centerline. The porcelain is not perfectly bilateral; it has different objects on either side.

GB: But it's been very carefully organized.

MW: It's organized, but the objects don't repeat.

GB: It's as close as he could have done, though. Look at how the two reclining figures on the second shelf from the bottom mirror each other.

WN: Any arrangement reflects the mind of the arranger. The glass image, as Michael correctly said, is bilaterally symmetrical. It's as if Talbot is showing an entire set for a large dinner table, inventorying the crystal that would be needed to serve the wine and other beverages. With the porcelains, his object was to show how eccentric the shapes and varieties are. An artist could not easily draw them, because they would challenge his or her ability to observe. Talbot has, as you said, created a kind of symmetry and arranged it in what would seem to be a logical way. But the bonnets had to have been arranged by somebody else. Wouldn't it make sense that women would have been the ones who would handle these? I suspect that they were arranged by their owners, and that's why the image looks different.

JF: Perhaps he was just being true to the materials he was photographing. The bonnets are cloth and more fluid; the glass and ceramics are hard.

LS: Talbot also made a similar picture of plaster casts (p. 133). They were newly popular in his day, and Lacock Abbey held an extensive collection of them.

DF: *The Fruit Sellers* (pl. 44), most likely from September 9, 1845, is yet again a very different kind of image. Apparently there is some dispute about who took this.

LS: *The Fruit Sellers* is actually a twentieth-century title. The contemporary name was *Group of Persons Selling Fruits and Flowers*. The September 9 date is my guess as to when this was done, because I believe it was taken the weekend that the Reverend Calvert R. Jones (see p. 135) and his wife visited Lacock Abbey. I can find no record of Talbot claiming authorship of this picture, but it certainly was very popular. A lot of prints were made of it at Reading.

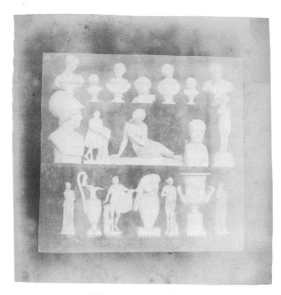

William Henry Fox Talbot.
Casts on Three Shelves in the Courtyard of Lacock Abbey, most likely 1842–44.
Salt print from a calotype negative, image: 13.5 × 13.9 cm (5⅜ × 5⅜ in.);
sheet: 18.1 × 17.9 cm (7⅛ × 7⅛ in.). 84.XZ.574.15.

The image was taken at Lacock, but the people are not typical of the residents there, with the possible exception of the reclining man, who looks a little like one of the gardeners. The man at the left in the dark suit appears in a lot of Jones's pictures in Wales. The whole structure of the image is not Talbot as I know him. So, lacking any evidence that Talbot did take this picture, I am inclined to think that it was either made by Jones or primarily impelled by him on this visit.

GB: So it was made at Lacock, but not necessarily by Talbot.

LS: I'm not even sure he was there that day.

GB: Really? But you're certain that it is Lacock.

LS: Yes.

WN: The problem of questioning the attribution of this picture using the logic that Larry has just employed is that it would seem to open others to the same question.

LS: Absolutely.

WN: So it really points to the dilemma of authorship. We have been talking so much today about aspects that are so fundamental to authorship, it seems essential that we form a consensus as to whether this picture could or could not have been by Talbot.

LS: I became interested in this question partially because the picture was marketed very heavily by the *Sunday Times*. Prints supposedly made from the original calotype negative were marketed through the *Times* as collector's items, and it was presented as a Talbot picture.

The first reference I can find to the image is December 13, 1845, when Henneman reports sending some prints of it to Talbot. This would argue for the September 9 date, because December would have been a reasonable period afterward. Later, Henneman sold the print publicly, so it did get wider circulation.

Of course, Talbot wanted other people to take photographs, and in fact he bought a lot of negatives from Jones and other people. This relates back to Nancy's comments earlier about Talbot's plans in France, where he envisioned artists creating the work and prints being sold through a central outlet.

WN: But here I think we have to pursue certain assumptions that either lead us in a direction and can be counted on or can't. Is there evidence of other Lacock images that were not made by Talbot to support the position for this not being by him? Because Lacock was his studio; it was where he worked. And what you're saying is that not only is Talbot not in the picture, perhaps he was not even present when this was made.

LS: This is the only widely known one, but there are about a dozen images like this, where groups of people are assembled at Lacock. They are all fairly late calotypes and are consistent with a lot of material that was very clearly done in Wales by Jones.

WN: Let's look at other circumstantial evidence. The print we're looking at was found at Lacock.

LS: Yes. Thousands of prints made by Henneman came back to Lacock in the 1850s when his business failed. Some of those packets weren't even opened until the 1960s, and Talbot may never even have seen some of the pictures. This one I know he did see.

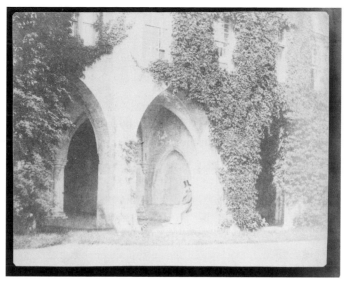

William Henry Fox Talbot.
The Ancient Vestry, Lacock Abbey, Wiltshire, 1845.
Salt print from a calotype negative, image: 16.5 × 20.7 cm (6½ × 8⅛ in.);
sheet: 18.5 × 22.6 cm (7¼ × 8⅞ in.). 84.XM.1002.16.
The figure in the image is the Reverend Calvert R. Jones.

GB: But among those pictures were prints made from negatives by others, right?

LS: Absolutely. And Talbot owned many negatives produced by others. There are hundreds by George W. Bridges and Jones alone.

NK: Would Talbot have seen this print at Reading?

LS: Yes, he saw it there. Talbot and Henneman both bought negatives for the Reading business to print.

NK: But we don't know from whom?

LS: We know some of them, but not all. In the Brewster Album, for example, there is a print Talbot made from a negative taken by a French artist. He doesn't name the artist, but he distributed the print pretty widely. That's not an unusual situation.

GB: This is a question that primarily applies to catalogers and museum professionals. It doesn't really bother me one way or the other if this is "of Talbot's time," because to identify it as being made by Talbot is only useful in terms of catalogues raisonnés and biographical histories. It is a fascinating image either way.

LS: My main argument here is that this image is in the style of Jones.

WN: Is it possible then that Jones is the author of other of the pictures that we think of as by Talbot?

LS: I've always suggested that possibility, and it's why my catalogue raisonné is called *Of the Circle of Talbot*.

WN: So what we're really talking about here is the reality that some of the very best pictures we've been discussing could be by somebody else. I would hate to see this be attributed to Circle of Talbot, which seems so indeterminate.

GB: But it speaks to the milieu that Talbot worked and prospered within. I mean, you could make a negative and give it to Talbot and he'd print it. This is a man who went to a lot of effort to disseminate his discovery within his own circle, and he was obviously very generous in terms of sending prints out and encouraging people to send them back. In that sense, it's not against the grain of Talbot's character.

You could say that all these images are from a certain milieu, an upper-middle-class, lower-aristocratic, educated circle. This image depicts rich folks pretending to be poor. The idea of the picturesque poor was a Victorian affectation, so the very subject matter here comes from a kind of class perspective that Talbot obviously shared with Jones and others of his circle. If you want to skip the question of authorship for a moment, this is a picture of their class. Only the upper class could imagine this would be a fun thing to do.

LS: The choreography here is not what I know as Talbot, but it is what I know as Jones. I think if Talbot were here today, he wouldn't really care whether he or Jones had taken this negative. He would celebrate the fact that his invention had been able to produce this.

DF: The final two pictures we're going to consider today take us back to where we began our discussion. The subject of *Two Leafy Stalks of Bamboo* (pl. 46), from 1852

or later, recalls the very first image we saw, but the stronger connection here is with Talbot's role as an inventor of photographic processes. Both this work and *Rosslyn Chapel, near Edinburgh* (pl. 47), from 1858 or later, are mechanically produced prints from processes Talbot developed.

LS: By the time of *The Pencil of Nature*, Talbot had discovered the fading problem his calotype process had, and he was eventually persuaded, particularly by some experiments that Thomas Malone conducted for him in the late 1840s, that printing in silver was not going to have the permanence that he wanted for book plates. Talbot went back to experiments that predated photography, and by 1852 he had devised the process he used for this botanical specimen, which he called photographic engraving. It was the forerunner of the photogravure process. He took a sensitized bichromated layer of gelatin on a metal plate and exposed it under a positive or, in this case, directly under a botanical example, as a photogram. After the exposure, he washed the plate; the gelatin in the parts where light had struck hardened, making it less soluble in water. The parts where light had not struck washed away. He then used a standard platinum-based gravure etchant to form an intaglio plate. This plate was filled with ink, which had stood the test of time in printing, and Talbot was able to make a print from it.

Rosslyn Chapel was done using a second process Talbot developed, photoglyphic engraving. It's Talbot's great method, the modern photogravure process. Briefly, he again started with the bichromated layer of gelatin on the metal plate, but after exposure he didn't wash the plate. Instead, he dusted it with a resin powder and fired it to form an aquatint ground. In the next step, which was Talbot's big breakthrough and is still used by printers today, he used an iron-based compound as an etchant. Much cheaper than the platinum compound, it also had the strange and counterintuitive effect on the unwashed gelatin that the more dilute he made it, the more quickly it operated.

The botanical print doesn't have a grain pattern and cannot be reproduced by the halftone process, but the plate for *Rosslyn Chapel* could make multiple prints for a modern book. And this was 1858!

GB: The complexity of the *Rosslyn Chapel* composition and the chiaroscuro make it an incredibly beautiful image.

WN: I agree, but there's nothing really like it in the rest of Talbot's work, which makes me wonder who made it. It's late; it was done at a time when he had passed the torch on to someone else. This surely must be an image he acquired from another photographer.

LS: Talbot sought positives from all sorts of folks. He used some of his own negatives to begin with, but except for a handful, all of his photographic and photoglyphic engravings are from other people's positives—and they number in the thousands. *Rosslyn Chapel* has always been one of my favorites. It's a very beautiful picture and an extremely interesting, original subject; it's also a very good photoglyphic engraving plate.

GB: It's interesting the way that he was pushing photomechanical printing away from personal expression and showing its ability to reproduce anybody's images. It's a very industrial approach to how photography was going to disseminate itself, I think.

WN: To me, the botanical specimen looks like a camera image. The minute that I learn, as Larry just suggested, that it is a photogram, the picture completely deflates. Are we dealing here with some attempt at an illusion? I see a dimensionality that is a result of the chiaroscuro, the different degrees of light and dark of the various leaves. I get a sense of a solid, dimensional plant.

MW: A photogram can yield a three-dimensional effect if you don't compress the object onto the sensitive surface, but allow it to stand proud and very carefully expose it to bright sunlight with no clouds, so you effectively have the point source of the sun and a big expanse of blue sky. You still get a sharp outline, because the sun is almost a point-source light, but the sky acts like a fill-in light.

WN: This image is roughly four by three inches, so this is a tiny plant. But it looks large. Is it incontrovertible that this could not have been photographed with a lens?

GB: Well, it's not incontrovertible, but since this was done around 1852, Talbot certainly wouldn't have taken it himself; he wasn't working behind the camera by then. It is conceivable that somebody sent him a small-sized negative of a plant taken in a camera.

LS: I think it's highly unlikely, but possible.

WN: If you were to find that in fact this plant is a photograph rather than a photogram, then its historical importance and its beauty become vastly greater. If this is a camera picture, it has an incredible forward-looking quality.

MW: But I think that it is possible to get this effect by making a photogram. And the fact that it has been printed as a positive rather than the original negative photogram is also significant.

WN: That's where I was headed next. If this is a photogram, why is this not a negative image?

LS: Photogravure is essentially a direct-positive process, if you want to think of it that way. Wherever light strikes the gelatin, it hardens it, and that area won't accept ink. What we're seeing here goes back to where Talbot started. We're seeing the shadow of the plant, not the plant itself, just as in the first image we viewed today.

These last two prints basically sum up what Talbot achieved during his photographic career. The botanical specimen is a unique contact print; the other image could be printed many times and be virtually everywhere. They reflect the course of photography in the twentieth century. The way Talbot was able to lay the foundations for the predominant nineteenth-century image-making process—photography and then in the latter part of his career lay the foundations for the dominant image-making process of the twentieth century—mechanical reproduction is really fascinating.

GB: He also had a connection with computing and therefore perhaps had a small role in the foundations of twenty-first-century image making too.

WN: These two pictures really do bring us full circle, and as we've gone through this great sequence of images, it's been fascinating for us to share how deeply Talbot has influenced the history of photography. He had to invent his materials to begin with, and then he had to learn to see both through them and with them. Thank you all for sharing your insights today about his brilliant accomplishments.

Chronology

1800
William Henry Fox Talbot is born on February 11 in Dorset, England, to Lady Elisabeth Fox Strangways and Captain William Davenport Talbot (who dies in July).

1802
Humphry Davy (1778–1829) publishes the pioneering work of Thomas Wedgwood (1771–1805) toward the invention of photography.

1804
Lady Elisabeth marries Captain Charles Feilding.

1807
William Hyde Wollaston (1766–1828) discloses his invention of the camera lucida.

1808
Talbot visits Lacock Abbey, the family's ancestral home, for the first time. Enters Rottingdean School, Sussex. His half sister Caroline Augusta Feilding is born.

1810
His half sister Henrietta Horatia Feilding is born.

1811
Enters Harrow School, with George Butler as headmaster.

1812
Causes explosion in Dr. Butler's house with chemical experiments and is banished to the blacksmith's.

1815–16
Leaves Harrow. Private tutoring at Castleford, Yorkshire.

1817
Private tutoring at Normanton, Lincolnshire.

1818
Enters Trinity College, Cambridge. Takes First Class in his freshman examinations.

1819
John Herschel (1792–1871) publishes the properties of hypo.

1820
Talbot wins Porson Prize for Greek verse.

1821
Comes into his majority and inherits an estate of £4,250 with an annual income of £1,800. Wins Second Chancellor's Classical Medal and graduates as 12th Wrangler.

1822
Elected a member of the Astronomical Society, London. Publishes first scholarly journal articles, in the *Annales de mathématiques.* In August is elected a member of the Royal Institution, London.

1824
Becomes a member of the Athenaeum Club, London. In September meets Herschel for the first time, in Munich.

1825
Receives M.A. from Cambridge. Conducts observations with François Arago (1786–1853) at the Paris Observatory.

1826
Herschel introduces him to Dr. David Brewster (1781–1868). In the *Edinburgh Journal of Science,* publishes his first scientific paper based on experiments, "Some Experiments on Coloured Flames."

1827

Regains control of Lacock Abbey. In France, Joseph-Nicéphore Niépce (1765–1833) makes the world's first photograph.

1829

Is elected a fellow of the Linnean Society, London. Niépce enters into a partnership with Louis Jacques Mandé Daguerre (1787–1851).

1830

Publishes his first book, *Legendary Tales, In Verse and Prose.*

1831

Is elected a fellow of the Royal Society, London. Defeated in first attempt at a seat in Parliament. In June, Herschel demonstrates the light sensitivity of platinum salts to Talbot and others, making a rudimentary ephemeral image.

1832

In December is elected to Parliament and marries Constance Mundy (1811–80).

1833

In June starts a six-month tour of the Continent. Conceives of the idea of photography while sketching with a camera lucida at Lake Como in October. Herschel departs for the Cape of Good Hope in November.

1834

Returns to Lacock Abbey in January and Parliament in February. During the spring starts photographic experiments at Lacock Abbey, with promising results. In the fall continues his research in Geneva and invents the *cliché verre* process.

1835

Does not stand for reelection to Parliament. In February records the concept of making prints from negatives and describes his photographic method as the "photogenic or sciagraphic process." In April his first

Memoranda (Talbot's pocket notebook), May 1834–June 5, 1838. 17.5 × 11.1 cm (6⅞ × 4⅜ in.). 84.XG.1003.2.

daughter, Ela Theresa, is born. During the summer achieves his first successes at producing photographs in a camera (one from August still survives).

1837

In March his second daughter, Rosamond Constance, is born. Awarded the Bakerian Prize by the Royal Society for his work on crystals. Charles Feilding dies in September.

1838

Publishes the first volume of *Hermes, or Classical and Antiquarian Researches.* Receives the Queen's Royal Medal, recommended by the Royal Society, for his work on integral calculus. By now has published nearly thirty scientific and mathematical papers. In November returns to his photographic research, with the intention of presenting a paper to the Royal Society.

1839

Arago announces Daguerre's process of photography in Paris on January 7. Talbot exhibits photogenic drawings at the Royal Institution on January 25; his first paper on photography (*Some Account of the Art of Photogenic Drawing*) is read before the Royal Society on January 31. On February 21, also at the Royal Society, reveals details of his process. His third daughter, Matilda Caroline, is born in February (and almost named Photogena). In March, Hippolyte Bayard (1801–87) invents the direct-positive process. In April, Talbot makes his first positive print from a camera negative. On August 19 Daguerre reveals the working details of his process. Talbot exhibits his photographs at the annual meeting of the British Association for the Advancement of Science. Publishes *The Antiquity of the Book of Genesis Illustrated by Some New Arguments* and the second volume of *Hermes, or Classical and Antiquarian Researches.* His photogenic drawings are exhibited in Edinburgh in December. Antoine-François-Jean Claudet (1797–1867) purchases the first license to practice daguerreotypy in England.

1840

Appointed high sheriff of Wiltshire. Discovers the leucotype, a direct-positive process, on September 17 and the fundamentals of the calotype process on September 20. Uses the term *latent picture* on September 23.

1841

Applies for a patent on the calotype on February 8. On June 10 reveals details of the calotype process to the Royal Society. Henry Collen (1800–1875) becomes the first licensed calotypist to take portraits in London.

1842

In February his son, Charles Henry, is born. The Royal Society awards Talbot the Rumford Medal for "many important discoveries made in photography."

1843

In June applies for a patent on further improvements in photography. Photographs in France and attempts to establish the calotype there. David Octavius Hill (1802–70) and Robert Adamson (1821–48) begin making calotypes in Scotland. Nicolaas Henneman (1813–98) leaves Talbot's employ and establishes a photography studio and printing laboratory at Reading in December.

1844

Publishes the first part of *The Pencil of Nature* in June. In October travels to Scotland to make photographs for a new book.

1845

Publishes the second part of *The Pencil of Nature* in January; the third, in May; the fourth, in June; and the fifth, in December. Issues *Sun Pictures in Scotland* by subscription in July. Also in July, travels with the Reverend Calvert R. Jones (1802–77), teaching him the calotype process.

1846

Lady Elisabeth dies in March. In April publishes the sixth, and final, part of *The Pencil of Nature.* In June the *Art-Union* issues seven thousand original prints. Talbot issues *The Talbotype Applied to Hieroglyphics* in August. Stops making photographs.

1847

In June patents the calotype in the United States. Publishes his last book, *English Etymologies.*

1849

Applies, with Thomas Malone (1823–67), for a patent on additional photographic processes.

1851

Attends the royal opening of the Great Exhibition in London on April 31. On June 12

applies for his last patent in photography, including an albumen-on-glass process and a method for taking pictures by electric flash. Demonstrates electric flash photography at the Royal Institution on June 14. Frederick Scott Archer (1813–57) publishes details of the wet-collodion process.

1852

In January wins patent case regarding calotypes. In August publicly gives up his photographic patent rights, except for commercial portraiture. Applies for patent for photographic engraving in October.

1854

Notes on the Assyrian Inscriptions is privately printed. In December loses patent fight regarding the wet-collodion process, which he believed infringed on his calotype protections.

1855

Wins Grande Medaille d'Honneur at the Exposition Universale, Paris. In October submits first scholarly article on Assyrian inscriptions. Starts living regularly in Scotland for the next decade and does most of his photomechanical research there.

1857

In February begins proceedings against the Photogalvanographic Company for patent infringement.

1858

In April applies for his last patent, for photo-glyphic engraving.

1859

Elected vice president of the Royal Society for Literature, London.

1862

Wins prize for his photoglyphic engraving at the International Exhibition, London.

Promotional Placard, 1862. Letterpress with two medals, 33 × 28.9 cm (13 × 11⅜ in.). 84.XM.1002.60.

1863

Receives honorary doctorate of laws from the University of Edinburgh.

1865

Wins prize for photoglyphic engraving at the Berlin International Photographic Exhibition.

1870

In December becomes founder/member of the Society of Biblical Archaeology, London.

1871

Publishes "Note on the Early History of Spectrum Analysis."

1872

Publishes his final scientific paper, on the Nicol prism.

1875

Publishes his final mathematical paper, on integer roots.

1877

On September 17 dies at Lacock Abbey, where he is buried.

Promotional Placard, about 1846.
Letterpress, 44.8 × 28.3 cm (17⅝ × 11⅛ in.).
84.XM.1002.61.

Editor	Gregory A. Dobie
Designer	Jeffrey Cohen
Production Coordinator	Stacy Miyagawa
Photographer	Ellen M. Rosenbery
Research Associate	Michael Hargraves
Printer	Gardner Lithograph
	Buena Park, California
Bindery	Roswell Bookbinding
	Phoenix, Arizona